BASIC PHOTO TEXT
BY KEN MUSE

2·00

10/18

PHOTO
ONE

PRENTICE-HALL INC., ENGLEWOOD CLIFFS, N.J.

10 9 8 7 6

ISBN 0-13-665331-6

Library of Congress Catalog No. 72-13191

Printed in the United States of America

PRENTICE-HALL INTERNATIONAL, INC., London
PRENTICE-HALL OF AUSTRALIA, PTY. LTD., Sydney
PRENTICE-HALL OF CANADA, LTD., Toronto
PRENTICE-HALL OF INDIA PRIVATE LTD., New Delhi
PRENTICE-HALL OF JAPAN, INC., Tokyo

THE AUTHOR, KEN MUSE, IS A COMMERCIAL ARTIST, A PHOTOGRAPHER, AND A CARTOONIST... AND HE TEACHES ALL THESE AT THE MACOMB COUNTY COMMUNITY COLLEGE IN WARREN, MICHIGAN! KEN, AT ONE TIME DREW A SYNDICATED COMIC STRIP CALLED "WAYOUT." HE HAS BEEN IN TV ART, ANIMATION, SLIDE FILM, ART STUDIOS, TECHNICAL ART.... AND ON LIVE TV!

THIS BOOK IS DEDICATED TO ALL ARTISTS AND PHOTOGRAPHERS WHO FIND HAPPINESS AND A REAL SENSE OF PRIDE IN THEIR WORK!

ACKNOWLEDGEMENTS

THE AUTHOR APPRECIATES THE COURTESY OF THE FOLLOWING COMPANIES FOR ALLOWING USE OF THE PHOTOS OF THEIR PRODUCTS:

LEICA CAMERAS
E. LEITZ, INC., N.J.

NIKON CAMERAS
NIKON/NIKKORMAT, N.Y.

CANON CAMERAS
BELL & HOWELL, CHICAGO

YASHICA CAMERAS
YASHICA INC., WOODSIDE, N.Y.

MINOLTA CAMERAS
MINOLTA CORP., N.Y.

MIRANDA CAMERAS
ALLIED IMPEX CORP., N.Y.

ALPA CAMERAS
KARL HEITZ INC., N.Y.

ROLLEIFLEX CAMERAS
ROLLIE OF AMERICA, N.J.

HASSELBLAD CAMERAS
PAILLARD INC., N.J.

EASTMAN KODAK PRODUCTS
EASTMAN KODAK, ROCHESTER, N.Y.

MAMIYA CAMERAS
EHRENREICH PHOTO OPTICAL, N.Y.

GOSSEM LIGHT METERS
KLING PHOTO CORP., N.Y.

WESTON LIGHT METERS
WESTON INSTRUMENTS, INC., N.J.

DURST ENLARGERS
PHOTO-TECHNICAL PRODUCTS, N.Y.

VIVITAR ENLARGERS
PONDER AND BEST INC., LOS ANGELES

OMEGA ENLARGERS
SIMMON OMEGA INC., N.Y.

BESELER ENLARGERS
BESELER PHOTO MARKETING INC., N.J.

TIME-O-LITE TIMERS
SINGER INDUSTRIAL TIMER DIV., N.J.

HOYA FILTERS
UNIPHOT INC., N.Y.

CONTENTS

AND OVER 100 FUNNY CARTOONS

AND DON'T FORGET THE TEAR-OUT MODEL RELEASE IN THE BACK!

THIS IS A VERY INFORMAL
PHOTO TEXT, NOT A COMPLETE
COURSE IN PHOTOGRAPHY
BY ITSELF, BUT IS TO BE USED
BY THE BEGINNING PHOTO
STUDENT IN CONJUNCTION WITH
THE PHOTO INSTRUCTOR!

BEGINNING PHOTO STUDENTS
SHOULD BE ENROLLED
IN OR STUDYING BASIC ART
COURSES IN COLOR AND
DESIGN, AS WELL AS FIGURE
DRAWING!
THE CAMERA IS A TOOL FOR
THE ARTIST!

TRY TO
THINK
OF
IT
AS A
TOOL!

SHUTTER SPEED

WHEN YOU PUSH THE BUTTON ON YOUR CAMERA TO TAKE A PICTURE, YOU ARE ALLOWING LIGHT TO COME IN AND STRIKE YOUR FILM FOR A CERTAIN DURATION OF TIME*THAT'S SHUTTER SPEED!*

THE SHORTER THE DURATION OF LIGHT HITTING YOUR FILM, THE SHARPER YOUR PICTURE IS GOING TO BE....*IT'S AS SIMPLE AS THAT!*

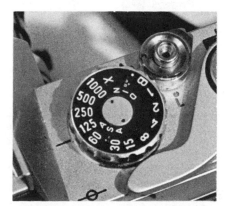

MOST 35mm CAMERAS HAVE THIS TYPE OF DIAL! THIS ONE IS AT 1/125

1

SHUTTER SPEED

WHEN YOU ARE A BEGINNER IN PHOTOGRAPHY, THE FIRST THING OF IMPORTANCE IS GETTING *SHARP PICTURES*..... IF YOU SPEND MONEY FOR A GOOD CAMERA, ...YOU DESERVE IT! SHOOT AT FAST SHUTTER SPEEDS LIKE 1/125, 1/250, 1/500, AND 1/1000th OF A SECOND

AND YOU'LL GET'EM!

HOWEVER, DON'T WORRY ABOUT THIS BEING THAT SERIOUS OF A PROBLEM ...YOU CAN SHOOT AT 1/30th AND EVEN 1/15th OF A SECOND IF YOU PRACTICE! ANY CAMERA WITH A COMPUR SHUTTER IS BEST FOR SLOW SHUTTER SPEEDS, SUCH AS THE TWIN-LENS REFLEX, OR 35mm RANGEFINDER CAMERAS, BECAUSE THERE IS NO JARRING DURING THE INSTANT OF EXPOSURE, CAUSED BY A MOVING CURTAIN, AND THE MIRROR BANGING UP!

IN THE **BEGINNING**, I'D **SUGGEST** USING A TRIPOD FOR THOSE SLOW SHUTTER SPEEDS!...THE BEST PIECE OF EQUIPMENT YOU CAN HAVE IS THAT *TRIPOD!*

SHUTTER SPEED

EVERY CAMERA TAKES A PICTURE BY USING A SHUTTER SPEED...."HOW LONG YOU ALLOW THE LIGHT TO HIT THE FILM BEFORE YOU STOP!" OF COURSE, THE SIZE OF THE HOLE THE LIGHT COMES INTO IS IMPORTANT... BUT NOT NEARLY AS IMPORTANT AS THE SHUTTER SPEED... *WHY?* BECAUSE ALL THE SIZE OF THE HOLE DETERMINES IS THE DEPTH OF FIELD... AND THAT MEANS: *"HOW MUCH OF THE PICTURE IS SHARPER THAN ANOTHER PART!"* BUT.....WITHOUT THE SHUTTER SPEED...YOU AIN'T GOING NOWHERE!

OF COURSE, YOU REALIZE YOU'RE NOT GOING TO GET A PICTURE WITHOUT BOTH, BECAUSE EACH ONE BY ITSELF, WON'T WORK!

AS A BEGINNER, YOU WILL SOON DISCOVER JUST HOW IMPORTANT THIS SHUTTER SPEED IS FOR A SHARP PICTURE!
WE'RE ASSUMING, OF COURSE, YOU FOCUS THE CAMERA CORRECTLY!

THERE IS NO SENSE IN TRYING TO PRINT PICTURES THAT AREN'T SHARP.......*UNLESS YOU WANT THEM THAT WAY!*
... NOW, TURN AND SEE THE MESS YOU CAN HAVE!

WHAT DO ALL THESE LITTLE NUMBERS AROUND THE LENS MEAN?

YOU ADD THEM ALL UP AND THAT'S THE PRICE OF THE CAMERA!

NEED A NEW CAMERA? TAKE OUT THAT SECOND MORTGAGE

KEN MUSE

SHUTTER SPEED

THIS IS THE CONTACT PRINT FROM A 2¼ X 2¼ NEGATIVE!

BELOW IS A 6X7 BLOW-UP OF THE SAME NEGATIVE! AS YOU CAN SEE, IT'S PRETTY SHARP, BEING EXPOSED AT f8 FOR 1/125 OF A SECOND!

THE FOLLOWING TWO PAGES WILL SHOW WHAT HAPPENS IN A 16X20 PRINT WHEN THE CAMERA IS HAND-HELD THROUGH ALL OF THE SHUTTER SPEEDS!

DON'T FORGET: USE A FAST SHUTTER SPEED!

SHUTTER SPEED

1
ONE SECOND
BAD CAMERA MOVEMENT!

2
HALF SECOND
STILL A MESS!

15
15th OF SECOND
BEGINNING TO SHARPEN-UP!

30
30th OF SECOND
WOULD BE OK FOR AN 8X10!

SHUTTER SPEED

125
125th OF SECOND
ACCEPTABLE SHARPNESS!

250
250th OF SECOND
THE 8X10 WAS BEAUTIFUL!

500
500th OF SECOND
REAL QUALITY!

1000
1000th OF SECOND
LOOK WHAT A FAST SHUTTER DOES!

SHUTTER SPEED

ASSUMING YOU KNOW HOW TO FOCUS YOUR CAMERA... THE SECRET OF GETTING A SHARP PICTURE IS REALLY VERY SIMPLE......

WHEN YOU ARRIVE ON THE SCENE WITH YOUR CAMERA, YOU LOOK AROUND AND SEE HOW MUCH LIGHT IS AVAILABLE........

THEN YOU USE THE FASTEST SHUTTER SPEED YOU CAN! NEVER MIND ABOUT THE LENS OPENING UNTIL *AFTER* YOU'VE PICKED THE SPEED!

...*AND THEN*... YOU CAN ADJUST YOUR LENS OPENING ACCORDING TO THE SHUTTER SPEED YOU'VE PICKED!!

SHUTTER SPEED

HAND HELD AT 1/30 → SAME NEGATIVE

BLOWN-UP TO 8X10, IT REALLY
DOESN'T LOOK TOO BAD!

BLOWN-UP TO 11X14..... NOTICE
HOW *FUZZY* IT IS?

CAMERA ON TRIPOD → SAME NEGATIVE

AND SHOT AT 1/30... NOTICE HOW
MUCH SHARPER.... IT'S THE TRIPOD!

IN THIS 11X14 PRINT IS WHERE THE
TRIPOD PROVES ITS WORTH!

SHUTTER SPEED

THESE NUMBERS STAND FOR THE PARTS OF A SECOND THAT YOUR SHUTTER IS OPEN! YOU DON'T NEED TO BE A WHIZ AT MATH TO SEE THAT 1/125 OF A SECOND IS FASTER THAN 1/8 OF A SECOND... OR THAT 1/2 OF A SECOND IS SLOWER THAN 1/500 OF A SECOND NOTICE ANOTHER THING ... EACH NUMBER IS APPROXIMATELY TWICE AS FAST OR HALF AS MUCH AS THE ONE RIGHT NEXT TO IT!

DON'T FORGET THAT!

OF COURSE YOU CAN'T SHOOT EVERY PICTURE AT 1000th OF A SECOND TO MAKE IT SHARPER BECAUSE OF LIGHTING CONDITIONS AND...

● THE SPEED OF THE FILM!

● HOW MUCH OF THE PICTURE YOU WANT TO BE SHARP!
AND....
● ARE YOU USING A TRIPOD?

HERE'S WHAT IT MEANS!

T TIME
B BULB
1 ONE SECOND
2 HALF SECOND
4 FOURTH OF SECOND
8 EIGHTH OF SECOND
15 15th OF SECOND
30 30th OF SECOND
60 60th OF SECOND
125 125th OF SECOND
250 250th OF SECOND
500 500th OF SECOND
1000 1000th OF SECOND

TIME MEANS YOUR SHUTTER STAYS OPEN UNTIL YOU PUSH IT AGAIN, AND THEN IT CLOSES.....
BULB MEANS YOUR SHUTTER STAYS OPEN UNTIL YOU TAKE YOUR FINGER OFF...THEN IT <u>CLOSES</u>!

9

SHUTTER SPEED

WHEN YOU TAKE A PICTURE WITH THE NORMAL LENS ON YOUR 35mm CAMERA AND BLOW IT UP TO 8X10, YOU'RE ENLARGING IT EIGHT TIMES! AND EVEN WHEN YOU SHOOT IT AT 1/60 OF A SECOND IT MAY LOOK SHARP TO YOU.... *BUT*.... WHEN YOU USE A TELEPHOTO LENS, YOU'RE ASKING FOR TROUBLE AT 1/60 OF A SECOND! IF YOU DON'T THINK SO STUDY THESE! WHEN USING A TELEPHOTO, USE 1/125 OF A SECOND, OR BETTER STILL, USE 1/250 OR 1/500 OF A SECOND! AND IF YOU HAVE A 1000th ON YOUR CAMERA...USE THAT.. EVEN IF YOU HAVE TO SHOOT THE PICTURE WITH THE LENS WIDE-OPEN.....OR NEAR IT!

400mm TELEPHOTO, HAND-HELD AT f8 FOR 1/60 OF A SECOND
NOTICE HOW FUZZY IT LOOKS IN THIS 11X14 PRINT?

HERE'S THE SAME SHOT AT f8 FOR 1/60...BUT THE CAMERA WAS
PUT ON A *TRIPOD*...WHAT'S WRONG WITH SHARP PRINTS?

SHUTTER SPEED

FOR EXAMPLE: IN THESE 400 mm TELEPHOTO SHOTS, HAND-HELD AT 1/60 OF A SECOND, I WAS ASKING FOR TROUBLE...NO MATTER HOW HARD I TRIED TO STEADY THE CAMERA! SINCE 400mm ON A 35mm CAMERA IS 8 POWER, MY SMALLEST MOVEMENT WAS MAGNIFIED 8 TIMES! A 135mm LENS WOULD BE 2.7 TIMES.....AND A 1000mm WOULD BE 20 POWER.... *A REAL MESS AT 1/30......* USE A TRIPOD OR A FAST SHUTTER SPEED..OTHERWISE, FORGET IT!

AND LOOK AT THIS MESS..I BLEW-UP THE HAND-HELD SHOT TO A 16X20 PRINT! WHO WANTS 16X20? *WHO WANTS FUZZ...?*

HERE'S THE *TRIPOD SHOT* IN A 16X20 PRINT...HOW ABOUT THAT?

SHUTTER SPEED

HERE ARE FOUR GOOD POINTERS TO REMEMBER WHEN SHOOTING AT A SLOW SHUTTER SPEED!

FOR A 35mm SINGLE LENS REFLEX, THAT MEANS 1/30 OF A SECOND AND SLOWER!

FOR A TWIN LENS REFLEX OR RANGEFINDER, THAT MEANS 1/15 OF A SECOND AND SLOWER!

LEAN AGAINST A *SOLID* OBJECT OR REST YOUR ELBOWS ON ONE!

HOLD YOUR BREATH AT THE INSTANT OF *EXPOSURE!*

WATCH FOR THE RIGHT MOMENT WHEN THE MOVEMENT IS LEAST!

PUT THE CAMERA ON A *TRIPOD!* THIS IS THE BEST WAY!

SHUTTER SPEED

THERE ARE VARIOUS METHODS TO SHOW MOTION IN A PHOTOGRAPH... SUCH AS PANNING WITH THE CAMERA AND CAUSING THE BACKGROUND TO BE BLURRED! THE OTHER IS HOLDING THE CAMERA STILL AND LETTING THE OBJECT BLUR WHEN IT MOVES ACROSS THE FIELD... *LIKE BELOW!!*

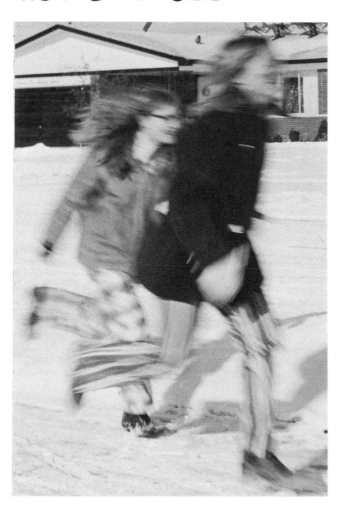

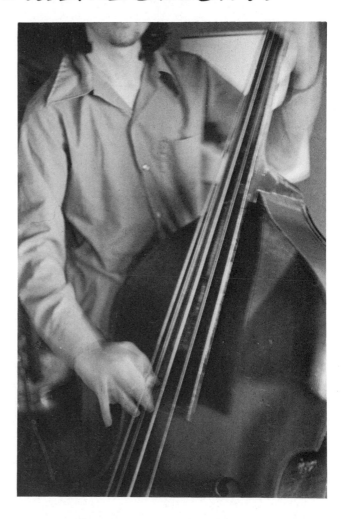

THIS ONE WAS SHOT AT 1/30 OF A SECOND AT f16! DON'T FORGET, WHEN YOU SHOOT AT A SLOW SHUTTER SPEED, YOU HAVE TO STOP YOUR LENS ALL THE WAY DOWN, SO PICK A SLOWER FILM... FOR THIS ONE I USED PLUS-X!

THERE IS NO DOUBT THE HAND IS MOVING! AS YOU CAN SEE, THIS TECHNIQUE IS VERY EFFECTIVE AND THAT IS BECAUSE EVERY— THING ELSE IN THE PICTURE IS SHARP! (1/15th OF A SECOND) NOTICE THAT THE LEFT HAND IS MOVING ALSO!

SHUTTER SPEED

HERE'S ANOTHER VERY EFFECTIVE METHOD TO SHOW MOTION IN A PHOTOGRAPH! IN THIS CASE THE CAMERA IS PANNED WITH THE SUBJECT AS IT MOVES ACROSS THE FIELD, CAUSING THE BACKGROUND TO BLUR INTO STREAKS AS BELOW! ALL METHODS ARE USED BY PROFESSIONS... *VARY THE SHUTTER SPEED!*

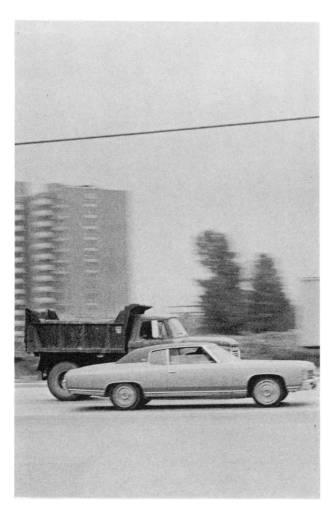 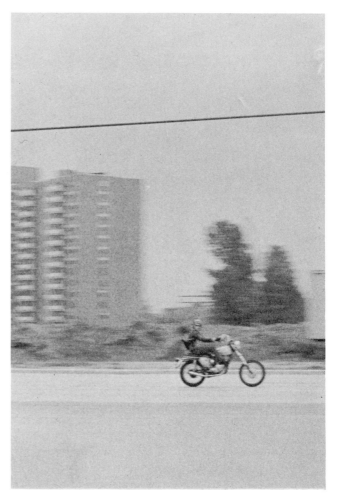

MOVING OBJECTS TRAVEL-ING DIRECTLY ACROSS THE FIELD FROM LEFT TO RIGHT, AS ABOVE, WILL BLUR EASIER, AND HAVE TO BE PANNED! THIS CAUSES THE BACKGROUND TO BLUR — 1/15 OF A SECOND

HERE'S A GOOD SHOT THAT GIVES THE FEELING OF SPEED! DON'T FORGET, WHEN YOU SHOOT AT A SLOW SHUTTER SPEED, YOU'RE ALSO USING A SMALLER APERTURE! *TRY THEM... THEY'RE FUN!*

APERTURE

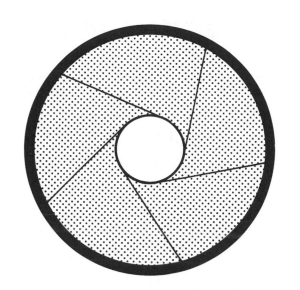

APERTURE IS THE SIZE OF THAT LITTLE HOLE INSIDE THE LENS ON YOUR CAMERA

IT IS ALSO REFERRED TO AS THE FOLLOWING:
- IRIS
- STOPS
- OPENING
- DIAPHRAGM

WHEN YOU USE A CERTAIN SIZED HOLE WITH A CERTAIN SHUTTER SPEED, YOU GET A PROPERLY EXPOSED NEGATIVE!

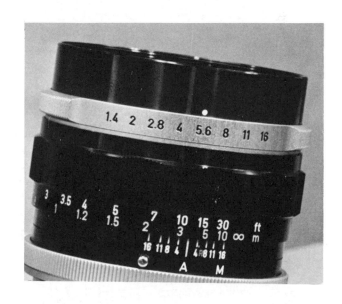

APERTURE

IN CASE YOU HAVEN'T NOTICED...THERE'S A HOLE IN **SIDE** OF THE LENS ON YOUR CAMERA! THIS HOLE IS ADJUSTABLE TO DIFFERENT SIZE OPENINGS! *AND YOU ARE THE ONE WHO DECIDES.......* SIMPLY PUT...IT'S THIS WAY: IF YOU WANT ALOT OF THINGS TO BE SHARP IN YOUR PICTURES, YOU HAD BETTER MAKE SURE THE HOLE IS *LITTLE!*AND IF YOU WANT JUST ONE THING IN YOUR PICTURE TO BE SHARP, YOU'DE BETTER MAKE SURE THE HOLE IS *WIDE OPEN!*

NOW... ALL THE DIFFERENT SIZED HOLES, FROM THE SMALLEST TO THE BIGGEST, WILL GIVE YOUR PICTURES DIFFERENT AREAS OF SHARPNESS! THESE HOLE SIZES WE CALL *STOPS* OR *APERTURE!*

I WANT YOU TO STUDY THE FOLLOWING PAGES AND SEE FOR YOURSELF EXACTLY WHAT HAPPENS IN YOUR PICTURE WHEN THE HOLE CHANGES!

APERTURE

THESE ARE CALLED ƒ NUMBERS, AND ARE SO ARRANGED THAT EACH TIME YOU CLICK THE LENS DOWN TO THE NEXT SMALLEST HOLE, THE LIGHT INTENSITY IS REDUCED BY EXACTLY ONE HALF.....AND EACH TIME YOU CLICK THE LENS OPEN TO THE NEXT BIGGEST HOLE, IT DOUBLES THE LIGHT INTENSITY!

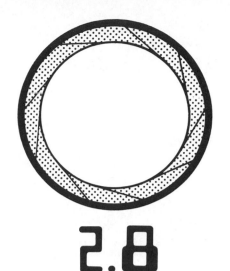

2.8

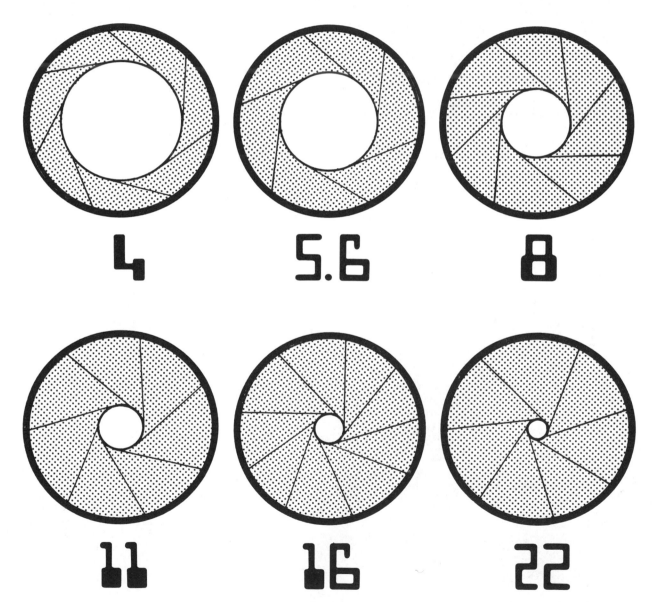

THESE ARE THE ƒ STOPS FROM A BRONICA 2¼ × 2¼

APERTURE

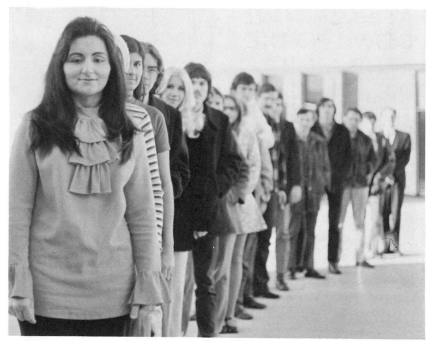

1/500 OF A SECOND

2.8

HERE'S A PICTURE WITH THE LENS WIDE OPEN AND FOCUSED ON THE GIRL IN FRONT! NOTICE THE **5**th STUDENT IS FUZZY!

MR. MEADOR, THE ART INSTRUCTOR, AT THE VERY END, IS COMPLETELY OUT OF FOCUS...IT'S HOPELESS!

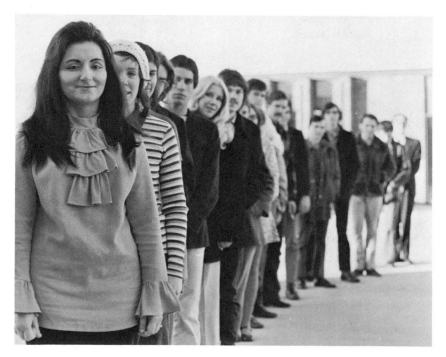

1/250 OF A SECOND

4

AT f4, THE 4th STUDENT IS SHARP, AND THE 5th STUDENT IS BEGINNING TO SHARPEN-UP!

MR. MEADOR IS STILL VERY BADLY OUT OF FOCUS... STILL HOPELESS!

APERTURE

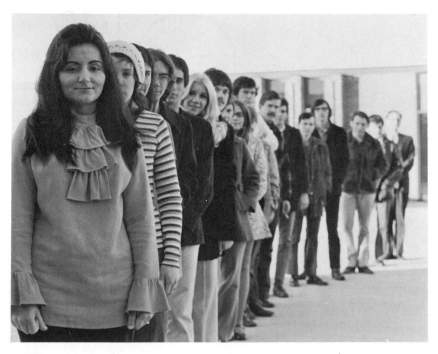

1/125
OF A SECOND

5.6

THERE IS NOW A REAL DIFFERENCE IN THE SHARPNESS! THE BLOND, LINDA, IS LOOKING GOOD!

MR. MEADOR IS FUZZY!

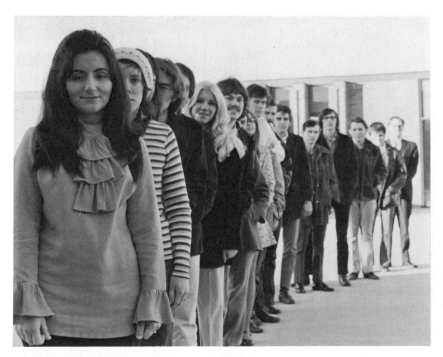

1/60
OF A SECOND

8

AT f 8, YOU CAN PRETTY WELL SEE WHO EVERYONE IS IN THE PICTURE!

MR. MEADOR IS STILL OUT OF IT!

APERTURE

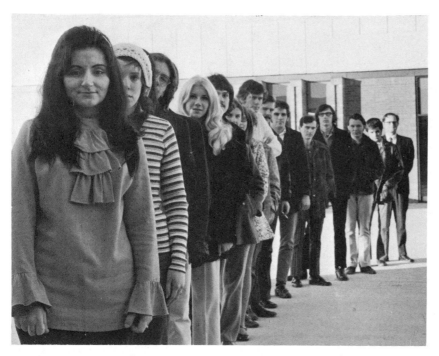

MR. MEADOR IS BEGINNING TO SHARPEN UP!

1/30 OF A SECOND

11

AH..HAA...THE MAGIC NUMBER: f11...THE STUDENTS IN THE REAR ARE SHARP ENOUGH TO MAKE THEM BUY ONE OF YOUR PRINTS!

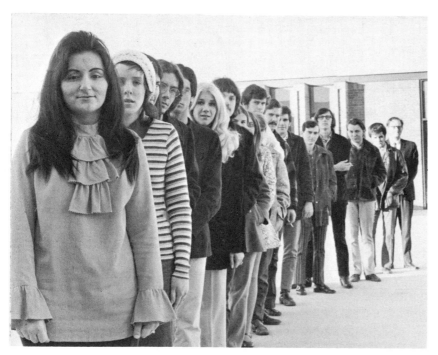

MR. MEADOR FINALLY MADE IT!

1/15 OF A SECOND

16

THIS IS MORE LIKE IT! THE STUDENTS, THE INSTRUCTOR, AND THE BUILDING ARE SHARP!

APERTURE

NOTICE AT f22 THAT *EVERYTHING LOOKS SHARP...* THE STUDENTS, MR. MEADOR, AND THE BUILDING!!! ALL OF THESE PICTURES WHERE SHOT ON A TRIPOD BECAUSE AT f22, MY SHUTTER SPEED WAS ONLY 1/8th OF A SECOND... *MUCH TOO SLOW TO HAND HOLD FOR SHARP PICTURES!*

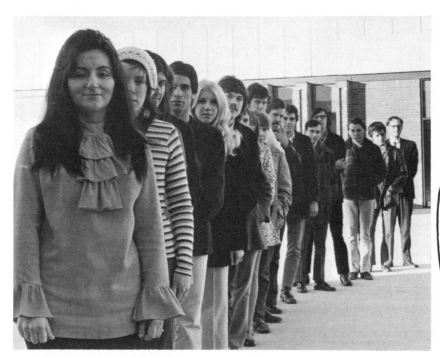

HI THERE, BILL!

1/8 OF A SECOND

22

THAT WAS THE FROSTING ON THE CAKE!

APERTURE

FULL STOP	1/3 STOP	1/2 STOP
f/1.4		
	f/1.6	
		f/1.7
	f/1.8	
f/2		
	f/2.2	
		f/2.46
	f/2.5	
f/2.8		
	f/3.2	
		f/3.4
	f/3.5	
f/4		
	f/4.5	
		f/4.9
	f/5	
f/5.6		
	f/6.3	
		f/6.9
	f/7	
f/8		
	f/9	
		f/9.8
	f/10	
f/11		
	f/12.5	
		f/13.5
	f/14	
f/16		
	f/18	
		f/19.6
	f/20	
f/22		
	f/25	
		f/27
	f/28	
f/32		

HERE'S AN INFORMATIVE CHART TO CHECK AND SEE IF YOUR LENS HAS **FULL f STOPS!**

APERTURE

HERE'S A TYPICAL EXAMPLE OF WHAT APERTURE CAN DO FOR YOUR PICTURE, ESPECIALLY WHEN YOU'RE TAKING PICTURES OF PEOPLE....AND YOU WANT THAT PROFESSIONAL LOOK........

 NOTICE THE CLUTTER IN THE BACKGROUND?

22

 NOW LOOK! SEE THE DIFFERENCE?

2.8

APERTURE

BELOW IS A SIMPLE SKETCH OF THE FACE OF A LIGHT METER! I SET MY METER FOR ASA 125, WHICH IS THE SPEED FOR PLUS-X FILM..... I HELD IT UP TO MY SUBJECT AND THE ARROW POINTED TO f5.6 FOR 1/250 OF A SECOND, AS YOU CAN SEE! THAT WOULD GIVE ME A PROPERLY EXPOSED NEGATIVE!

BUT LOOK..... ALL THE OTHER COMBINATIONS ON THE DIAL WILL DO THE SAME THING TOO!.....TAKE YOUR PICK ACCORDING TO THE EFFECT YOU WANT!

REMEMBER...... WHEN YOU TURN THE MIDDLE DIAL TO CHANGE THE ASA TO A DIFFERENT NUMBER, IT'S CONNECTED TO THE APERTURE AND ARROW DIAL WHICH ALSO MOVE!

FOR EXAMPLE:
IF YOU CHANGED THE ASA TO THE NEXT HIGHEST NUMBER..WHICH IS ASA 250..THE APERTURE AND ARROW DIAL MOVE TO f8...AND THE SHUTTER SPEED WOULD STAY AT 1/250th OF A SECOND!.......

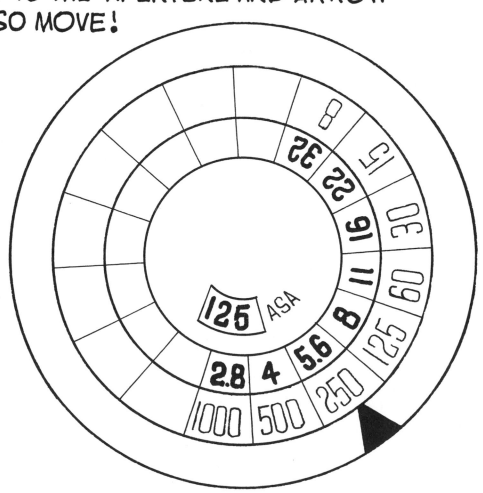

APERTURE

THE FOLLOWING **PAGES** DEMONSTRATE EXACTLY WHAT
HAPPENS IN A PICTURE AS THE APERTURE GETS SMALLER!
I PUT THE CAMERA ON A TRIPOD AND FOCUSED ON THE
FIRST BOX OF EKTACHROME-X FILMTHEN I KEPT
STOPPING DOWN THE LENS AND USING A SLOWER AND
SLOWER SHUTTER SPEED.... BEGINNING WITH 1/500th
OF A SECOND! THE DISTANCE BETWEEN THE FIRST AND
LAST BOX OF FILM IS ABOUT EIGHTEEN INCHES!

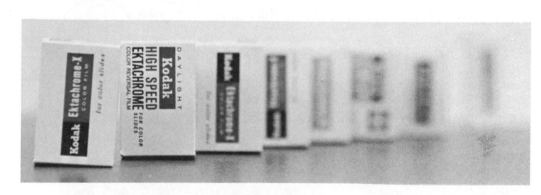

2.8

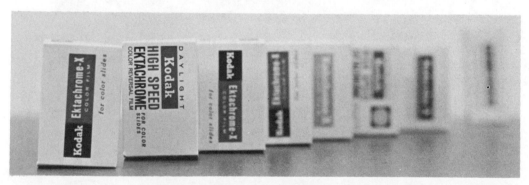

4

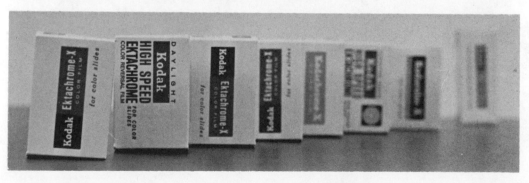

5.6

APERTURE

NOTICE HOW THE TRI-X FILM BOX IN THE BACK GETS SHARPER AND SHARPER AS THE APERTURE GETS SMALLER AND SMALLER!... BUT EVEN AT f22 IT NEVER GETS AS SHARP AS THE FIRST BOX OF EKTACHROME-X.... *REMEMBER THAT!*

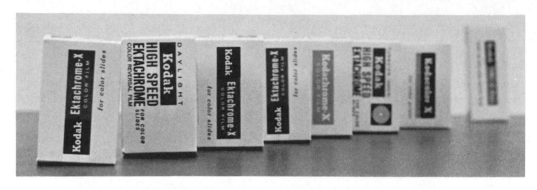

8

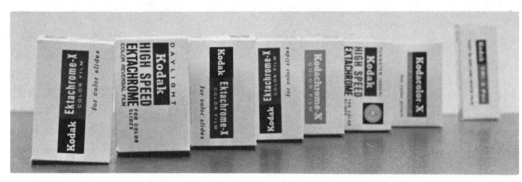

11

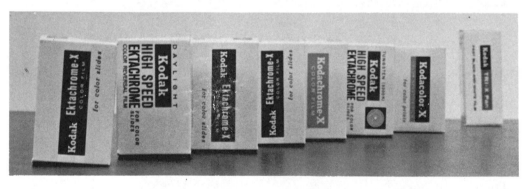

16

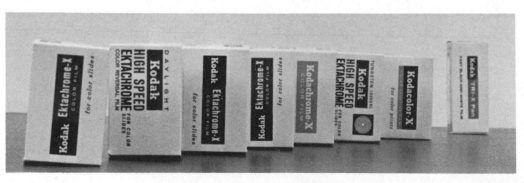

22

APERTURE

HERE'S ANOTHER EXAMPLE OF WHAT IT LOOKS LIKE WHEN YOU FOCUS ON DIFFERENT BOXES WITH THE LENS WIDE OPEN, AND STOPPED ALL THE WAY DOWN! *ARROWS SHOW WHERE I FOCUSED!*

2.8

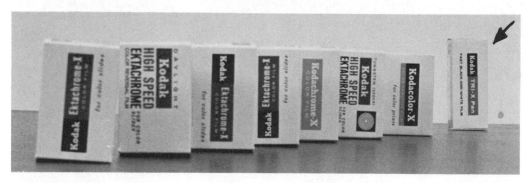

22

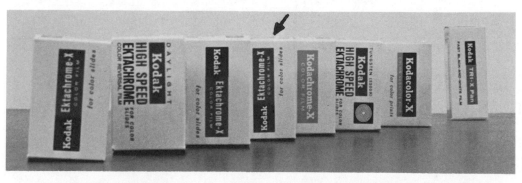

22

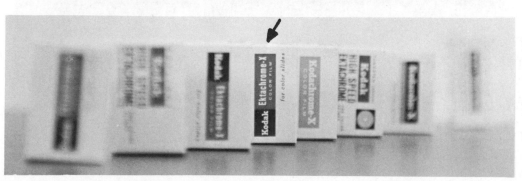

2.8

APERTURE

FOR EXAMPLE....LOOK AT THE PICTURE OF ALL THE STUDENTS...OR THE FILM BOXES...WHAT DO YOU WANT SHARP?... HOW MUCH DO YOU WANT SHARP? OR LET'S PUT IT THE CORRECT WAY: "HOW MUCH DEPTH OF FIELD DO YOU WANT?" YOU MAY NOT SHOOT FILM BOXES BUT YOU *WILL* SHOOT PEOPLE!

REMEMBER: THE FARTHER THINGS ARE AWAY, THE MORE DEPTH OF FIELD YOU'LL GET.... *AND....* THE CLOSER YOU GET, THE LESS DEPTH OF FIELD YOU'LL GET...THAT MEANS A SMALLER OPENING AND A SLOWER SHUTTER SPEED TO COMPENSATE!
AND THE SLOWER SHUTTER SPEED MEANS USING A TRIPOD!

APERTURE CONTROLS *ONE THING...* AND THAT IS *DEPTH OF FIELD!*
IT DOESN'T MAKE ANY DIFFERENCE WHAT YOUR SHUTTER SPEED IS.....
IT DOESN'T MAKE ANY DIFFERENCE WHETHER YOUR EXPOSURE IS GOOD OR BAD.....
YOUR DEPTH OF FIELD IS CONTROLLED BY *APERTURE!*

THE SMALLER THE HOLE THE MORE DEPTH!
THE BIGGER THE HOLE THE LESS DEPTH!

WHAT'S A SHUTTER?

IN BETWEEN THE LENS IS THE SHUTTER, WITH AN INGENIOUS SYSTEM OF GEARS, CAMS, SPRINGS AND LEVERS THAT SUDDENLY SPRING OPEN AND LET THE LIGHT HIT THE FILM! THEN AFTER A CERTAIN TIME GOES BY......LIKE 1/60 OF A SECOND, THE BLADES SPRING SHUT.... CUTTING OFF THE LIGHT AND ENDING EXPOSURE!

ACTUALLY, THE SHUTTER IS IN THE SAME HOUSING AS THE DIAPHRAGM, *AND THEY WORK TOGETHER!*

WHAT'S A DIAPHRAGM?

THE DIAPHRAGM, AS IT IS CALLED, IS SIMPLY A DEVICE USED TO CHANGE THE SIZE OF THE HOLE THAT THE LIGHT PASSES THROUGH! IT CONSISTS OF A BUNCH OF THIN METAL OR COMPOSITION SHEETS ATTACHED TO A RING SO THAT IT FORMS A CIRCULAR OPENING! WHEN YOU ROTATE THE RING, IT CAUSES THE HOLE TO CHANGE SIZES!

THIS WHOLE MESS IS MOUNTED INSIDE THE BARREL BETWEEN THE LENS ELEMENTS!

YOU MUST USE BOTH OF THESE TOGETHER FOR A CORRECT EXPOSURE!

CAMERA

ANY CAMERA...NO MATTER WHAT THE COST, IS ONLY A LIGHT-TIGHT BOX WITH FILM HELD FLAT IN THE BACK AND A LENS IN THE FRONT WITH A DEVICE TO REGULATE THE AMOUNT OF LIGHT THAT COMES IN......AND THE DURATION....THE MORE MONEY THEY COST, THE BETTER THE WORKMANSHIP AND THE MORE VERSATILE THEY ARE!... AS FAR AS SHARPNESS IS CONCERNED, YOU'D BE HARD PRESSED TO TELL THE DIFFERENCE BETWEEN A $150 AND A $300 CAMERA!

CAMERA

CAMERA

35mm SLR: $150-$650

NEGATIVE SIZE IS ROUGHLY 1 X 1 3/8 INCHES!..HAS
TO BE BLOWN-UP 8 TIMES FOR AN 8X10 PRINT!
A LOT OF DUST AND HAIRS TO WORRY ABOUT ON
THE PRINT! SHUTTER SPEEDS USUALLY GO UP
TO 1000th OF A SECOND, PLUS FAST LENSES...
HOWEVER, THE LENSES COME OFF, AND YOU CAN
ADD WIDE-ANGLE AND TELEPHOTO LENSES....
... *GREAT FOR THE BEACH!* EXPOSURE METERS
ARE BUILT RIGHT INTO THE CAMERA ...JUST MATCH
THE NEEDLE .. VERY HANDY........SOME ARE
COMPLETELY AUTOMATIC... POINT AND SHOOT!
THESE CAMERAS ARE JUST LIKE TELESCOPES, IN
THAT YOU LOOK RIGHT THROUGH THE LENS!

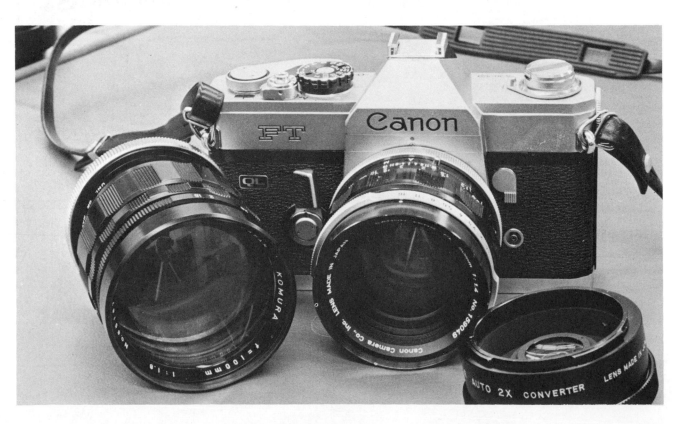

CAMERA

2¼ × 2¼ SLR: $350-$1300

BIG SQUARE NEGATIVE THAT ONLY HAS TO BE BLOWN-UP A LITTLE OVER 4 TIMES FOR AN 8X10 PRINT! HAIRS AND DUST NOT THAT MUCH OF A PROBLEM COMPARED TO 35mm NEGATIVES! IF YOU'VE GOT MONEY, THIS IS A GOOD CHOICE! IT HAS INTERCHANGEABLE LENSES, JUST LIKE THE 35mm SLRS.. BUT MORE EXPENSIVE! THOSE NEGATIVES ARE A PURE JOY TO PRINT!... MOST HAVE AN f 2.8 LENS..... SOME HAVE A 1/1000th OF A SECOND SHUTTER SPEED!
IT'S QUITE AN EXPERIENCE TO PUT ON A LONG LENS AND LOOK THROUGH THE GROUND GLASS!

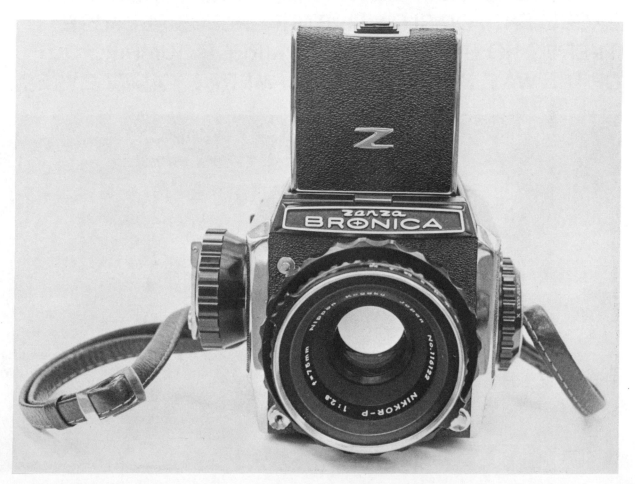

CAMERA

35mm RANGEFINDER: $100-$600

NEGATIVE SIZE IS ROUGHLY 1X1 3/8 INCHES!... HAS TO BE BLOWN-UP 8 TIMES FOR AN 8X10 PRINT!... A LOT OF DUST AND HAIRS TO WORRY ABOUT ON THE PRINT! SHUTTER SPEEDS ARE USUALLY UP TO 500th OF A SECOND... THE EXPENSIVE ONES GO TO 1000th OF A SECOND!.. YOU CAN'T FOCUS THROUGH THE LENS LIKE YOU CAN WITH A SLR; INSTEAD YOU MATCH TWO IMAGES TOGETHER IN THE VIEW FINDER.... NOT A VERY GOOD CHOICE FOR CLOSE-UP WORK OR COPYING! MOST FOCUS NO CLOSER THAN 2½ FEET.... MOST SLRS FOCUS TO 18 INCHES... AND SOME TO 7 INCHES! EXCELLENT FOR SLOW SHUTTER SPEEDS BECAUSE THERE'S NO BANGING OF THE MIRROR JUMPING OUT OF THE WAY, JARRING THE CAMERA! *FAST LENSES!*

CAMERA

2¼ × 2¼ TLR: $100 - $500

I USUALLY RECOMMEND THE TWIN-LENS REFLEX
BECAUSE IT HAS A BIG NEGATIVE, IT'S EASY TO
LOAD, EASY TO OPERATE, EASY TO BLOW-UP,
AND EASY ON THE WALLET! UNFORTUNATELY,
THE LENSES DON'T COME OFF.... YOU'RE STUCK
WITH THE ONE LENS! THE ONLY EXCEPTION
BEING THE MAMIYA-C33, WHICH LISTS FOR
$285! *A BIG NEGATIVE WILL BEAT A LITTLE
NEGATIVE ANYDAY!!!!........*

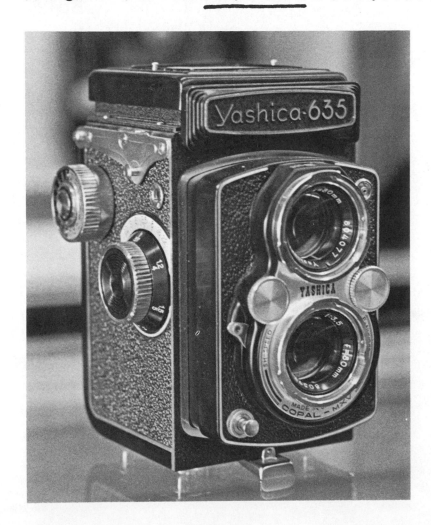

CAMERA

HERE'S A 35mm SHOT
WITH A CANON FT-QL
AND A 50mm f1.4....
f11 AT 1/500 OF SEC.
TRI-X FILM!

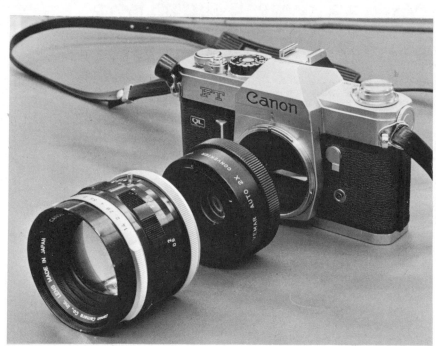

NOW WE PUT ON AN AUTO-
MATIC 2X CONVERTER,
MAKING THE NORMAL LENS
A 100mm BUT BY
DOING SO, LIKE ALL THESE
CONVERTERS...WE LOSE
TWO STOPS..MAKING THE
f1.4 LENS INTO AN f2.8!
COSTS ABOUT $15⁰⁰

HERE'S THE SAME SHOT!
BUT NOW IT'S A 100mm
TELEPHOTO...SHOT AT
f5.6 AT 1/500 OF SEC.!
NOT BAD FOR $15⁰⁰

*THESE ARE 8X10
BLOW-UPS!*

CAMERA

HERE'S A SHOT WITH A 35mm CAMERA USING THE *NORMAL* 50mm LENS....TRI-X FILM!!!

HERE'S THE SAME SHOT WITH A 200mm LENS!....EVERYTHING IS FOUR TIMES CLOSER!

CAMERA

AND THE SAME SHOT WITH A FORTY DOLLAR 400mm LENS! NOW IT'S EIGHT TIMES BIGGER!

AND NOW THE 400mm LENS WITH A 2X TELE-EXTENDER! COSTS ABOUT $15.. BUT NOTICE THE HOT SPOT ON TRUCK?..

CAMERA

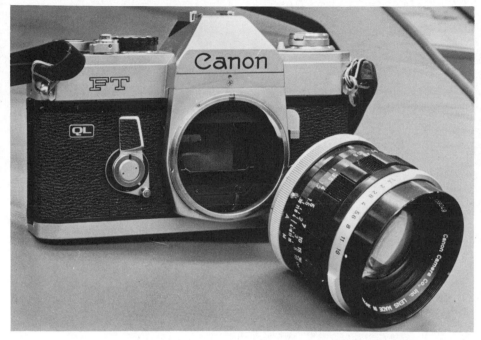

HERE IS A 35mm SINGLE-LENS RE-FLEX CAMERA WITH THE LENS REMOVED! MOST STUDENTS USE THESE CAMERAS BECAUSE DIFFERENT LENSES SUCH AS TELEPHOTOS AND WIDE-ANGLES CAN BE USED! *NOTE MIRROR INSIDE!*

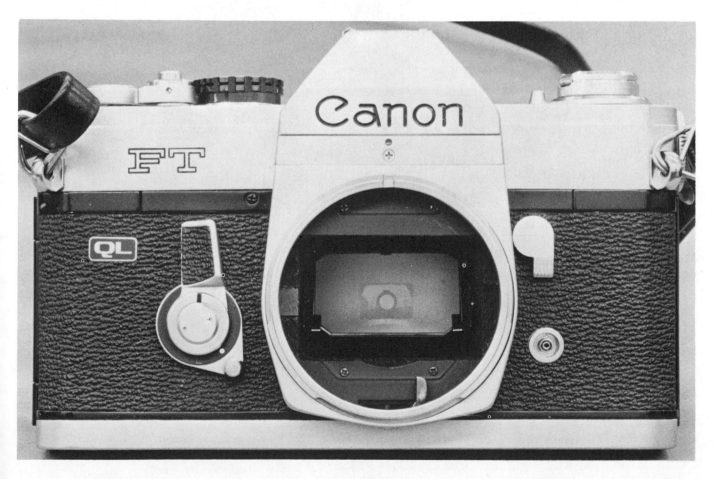

CAMERA *THIS TEST DEVELOPED IN ACUFINE!*

THERE'S A DIFFERENCE BETWEEN A BIG NEGATIVE AND A LITTLE NEGATIVE AND THE DIFFERENCE IS GRAIN... *HERE'S THE BIG NEGATIVE!* TRI-X FILM!

2¼ NEGATIVE 8X10

2¼ NEGATIVE 11X14

2¼ NEGATIVE 16X20

CAMERA THE PITFALLS OF TRI-X ON A BRIGHT SUNNY DAY WITH 35mm

NOW, TAKE A LOOK AT THESE SHOTS...THERE'S NOT TOO MUCH DIFFERENCE IN SHARPNESSBUT, LOOK AT ALL THE GRAIN! *THIS IS THE 35 NEGATIVE!*

35mm NEGATIVE 8X10

35mm NEGATIVE 11X14

35mm NEGATIVE 16X20

CAMERA

INCLUDED HERE IS A SHOT TAKEN WITH A **BOX** CAMERA.....
IN OTHER WORDS, THE f STOP IS ABOUT f16, AND THE
SHUTTER SPEED IS ABOUT 125th OF A SECOND! BESIDES
THIS, ANYTHING CLOSER THAN 4 FEET IS OUT OF FOCUS!

HERE'S A 4X5 PRINT FROM THE BOX
CAMERA...DOESN'T LOOK TOO BAD!

HERE'S THE 8X10 ENLARGEMENT FROM THE
SAME BOX CAMERA NEGATIVE! *NOW YOU SEE!*

AND HERE'S A 4X5 PRINT FROM A
35mm FOCUSING CAMERA...SHARP!

THE 8X10 FROM THE SAME NEGATIVE! THIS
IS WHAT A FOCUSING CAMERA CAN DO!

BOX CAMERAS ARE FUN, LIGHT, AND EASY TO USE!

CAMERA

BELOW ARE VARIOUS TYPES OF CAMERAS.... SOME NEW AND SOME USED! ALL OF THESE CAMERAS FOCUS, HAVE SHUTTER SPEEDS AND f STOPS! THEY ALL WILL TAKE SHARP PICTURES AND WILL PRODUCE PROFESSIONAL RESULTS IF USED CORRECTLY!
REMEMBER... THERE IS NO **ONE** PROFESSIONAL CAMERA... BUT THERE ARE PROFESSIONALS **USING** CAMERAS!

THIS KODAK INSTAMATIC IS NON-FOCUSING

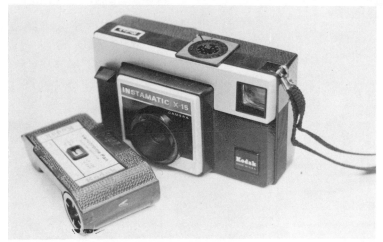

CAMERA

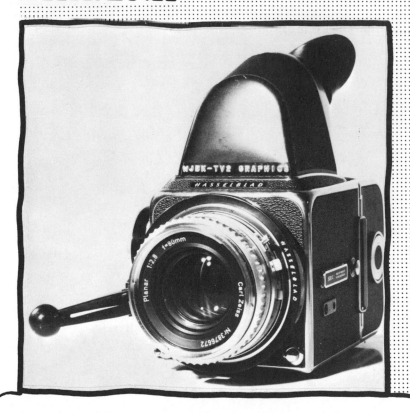

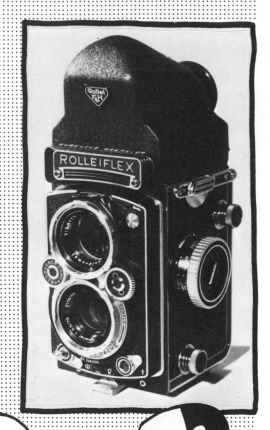

HERE ARE MORE CAMERAS THAT ARE USED BY AMATEURS AND PROFESSIONAL PHOTOGRAPHERS ALIKE.... REMEMBER, IF NOT USED CORRECTLY, A $500 CAMERA WILL TAKE LOUSY PICTURES!

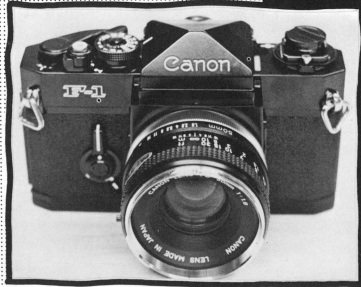

CAMERA

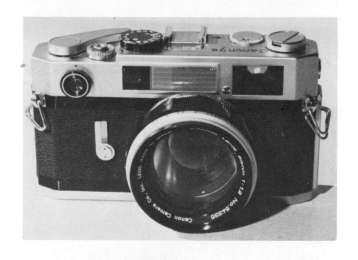

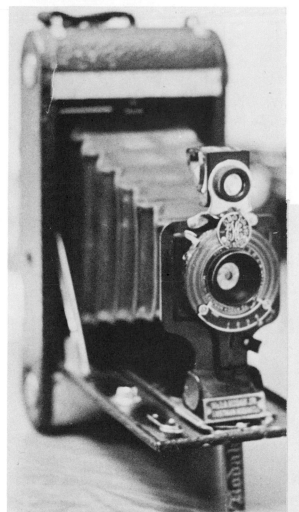

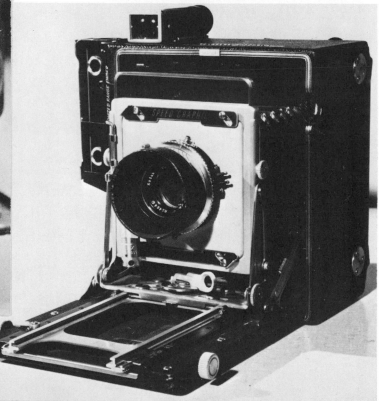

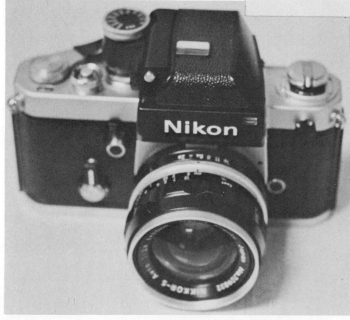

THESE ARE MORE OF
THE SAME IN USED
CAMERAS!
AS I SEE IT... A GOOD
USED CAMERA IS THE
BEST INVESTMENT YOU
CAN MAKE!
YOU GET MORE FOR
YOUR DOLLAR!

CAMERA
WHAT KIND SHOULD I BUY?

FIRST OF ALL, THE CAMERA THAT YOU BUY.... OR HAVE...SHOULD BE ABLE TO *FOCUS!* YOU KNOW WHAT THAT MEANS, DON'T YOU? IT MEANS YOU CAN MAKE ONE THING SHARP IN YOUR PICTURE BY TURNING THE LENS LEFT OR RIGHT!
AND SECONDLY, IT SHOULD HAVE A HOLE IN BETWEEN THE LENS THAT YOU CAN MAKE SMALLER OR BIGGER! *CALLED A "DIAPHRAGM."*
AND LAST, BUT NOT LEAST..... IT SHOULD HAVE A SHUTTER SPEED LEVER OR DIAL OF SOME KIND, THAT VARIES THE DURATION OF THE LIGHT THAT COMES IN THE HOLE AND HITS THE FILM!

AND ALL THESE THINGS CAN BE CHANGED AND RESET IN VARIOUS COMBINATIONS!

I ALWAYS ADVISE MY STUDENTS TO CHOOSE A BIG NEGATIVE, AS IT DOESN'T NEED AS BIG AN ENLARGEMENT TO GET TO 8X10 AS A 35mm NEGATIVE DOES! ANOTHER THING IS THEY AREN'T AS EXPENSIVE AS A 35 SLR WITH INTERCHANGEABLE LENSES!

I ALSO SUGGEST INVESTIGATING GETTING A USED CAMERA INSTEAD OF A NEW ONE.... FROM A GOOD CAMERA STORE THAT WILL STAND BEHIND THEIR USED MERCHANDISE!

PRESET NON-FOCUSING.... OR "**BOX**" CAMERAS, AS THEY ARE CALLED, CAN BE VERY DISAPPOINTING TO A SERIOUS AMATEUR BECAUSE WHEN YOU MAKE ENLARGEMENTS, THEY ARE NOT SHARP!

46

NEW OR USED CAMERA?

THAT'S A GOOD QUESTION.... AND I CAN ONLY RELATE MY PERSONAL EXPERIENCE, JUST AS ANYONE WOULD!

CAMERA STORES HAVE ALL SORTS OF USED PROFESSIONAL EQUIPMENT AND CAMERAS THAT ARE REAL BARGAINS FOR THE AMATEUR, AND SHOULD BE CONSIDERED AS A *FIRST* PURCHASE!

FOR EXAMPLE:

AN EXPENSIVE 35mm SLR CAMERA WITH A FAST f1.4 LENS, SELLING FOR AROUND $500 NEW, CAN BE PURCHASED FOR NEAR HALF THE PRICE AT A REPUTABLE CAMERA STORE ... AND A GUARANTEE BY THAT CAMERA STORE! *A WISE BUY.......*

ALL CAMERAS PICTURED IN THIS BOOK ARE USED!

HE'S VERY LIKELY USING USED FILM!

47

CAMERA

HERE ARE JUST A FEW THINGS TO LOOK FOR WHEN BUYING A USED CAMERA!

SHAKE THE CAMERA AND LENS .. AND CHECK FOR RATTLES....

IT'S ONLY GLASS!

LISTEN FOR FUNNY SOUNDS WHEN YOU WORK THE SHUTTER SPEEDS....

CHECK AND SEE IF INFINITY IS REALLY INFINITY!

CHECK FOR DENTS!

FILM

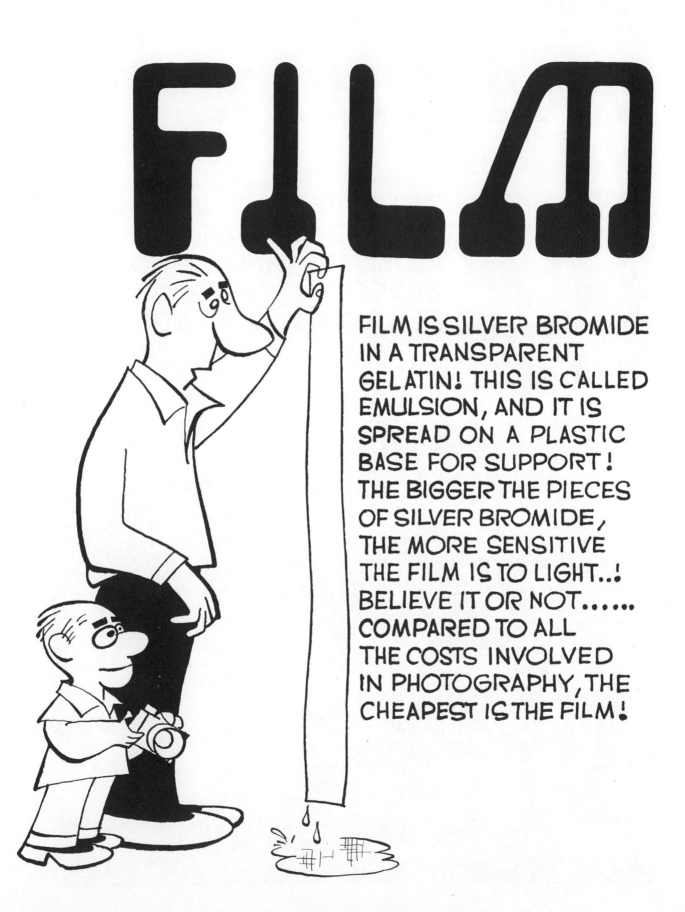

FILM IS SILVER BROMIDE IN A TRANSPARENT GELATIN! THIS IS CALLED EMULSION, AND IT IS SPREAD ON A PLASTIC BASE FOR SUPPORT! THE BIGGER THE PIECES OF SILVER BROMIDE, THE MORE SENSITIVE THE FILM IS TO LIGHT..! BELIEVE IT OR NOT...... COMPARED TO ALL THE COSTS INVOLVED IN PHOTOGRAPHY, THE CHEAPEST IS THE FILM!

FILM
PANATOMIC-X
ASA 32

THIS IS THE FILM TO USE WHENEVER A HIGH DEGREE OF ENLARGEMENT IS REQUIRED! ALL THESE FOUR FILMS WERE SHOT AT THE RECOMMENDED FILM RATING! SHOT WITH A *BRONICA!*

FILM
PLUS-X PAN
ASA 125

THIS IS A MEDIUM-SPEED PANCHROMATIC
FILM WITH EXCELLENT GRADATION.......
EXTREMELY FINE GRAIN, HIGH DEFINITION,
AND WELL SUITED FOR BIG BLOW-UPS!

FILM

TRI-X PAN
ASA 400

THIS IS A HIGH-SPEED, FINE GRAIN FILM,
IDEAL FOR DIMLY LIGHTED SUBJECTS,
FAST SHUTTER SPEEDS, GREAT DEPTH OF
FIELD OR COMBINATION OF BOTH...THIS
FILM IS INTENDED FOR ADJUSTABLE
SHUTTER SPEEDS AND LENS OPENINGS!

8X10 ENLARGEMENT!

FILM
ROYAL-X PAN
ASA 1250

THIS *NEW* IMPROVED EXTREMELY FAST, MEDIUM-GRAIN, PANCHROMATIC ROLL FILM IS RECOMMENED FOR NIGHT SPORTS ACTION, INTERIOR SCENES, AND VERY BAD LIGHTING!

NOT AVAILABLE IN 35mm

8X10 ENLARGEMENT!

FILM

AS YOU HAVE PROBABLY NOTICED... YOU WOULD HAVE A TOUGH TIME TELLING THE DIFFERENCE BETWEEN THESE FILMS IN AN 8X10 PRINT.......

PANATOMIC-X
16X20 ENLARGEMENT!

PLUS-X PAN
16X20 ENLARGEMENT!

FILM

HERE IN THESE 16X20 PRINTS YOU CAN SEE THE GRAIN BETTER! THE ROYAL-X PAN FILM ISN'T TOO BAD FOR 1250 ASA YOU'LL ADMIT!

TRI-X PAN
16X20 ENLARGEMENT!

ROYAL-X PAN
16X20 ENLARGEMENT!

FILM

PANATOMIC-X
ASA 32
DEVELOPING TIME IN MINUTES

	65F	68F	70F	72F	75F
D-76	8	7	6½	6	5
D-76 (1:1)	11	9	8	7	6

PLUS-X PAN PROFESSIONAL
ASA 125
DEVELOPING TIME IN MINUTES

	65F	68F	70F	72F	75F
D-76	6½	5½	5	4½	3¾
D-76 (1:1)	8	7	6½	6	5

FILM

TRI-X PAN
ASA 400
DEVELOPING TIME IN MINUTES

	65F	68F	70F	72F	75F
D-76	10	8	7	6	5
D-76 (1:1)	13	11	10	9	8

ROYAL-X PAN
ASA 1250
NOTE: DO NOT DEVELOP FOR LESS THAN 5 MINUTES

	65F	68F	70F	72F	75F
HC-110 (DILUTION B)	10	9	8	7½	6½
HC-110 (DILUTION A)	6	5	4¾	4½	4¼

STAY RIGHT THERE, I HAVE A ZOOM LENS!

FILM

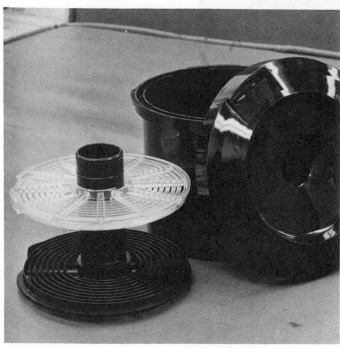

THIS IS THE SELF LOADING KIND OF TANK.......JUST TURN IT BACK AND FORTH TO LOAD THE FILM....

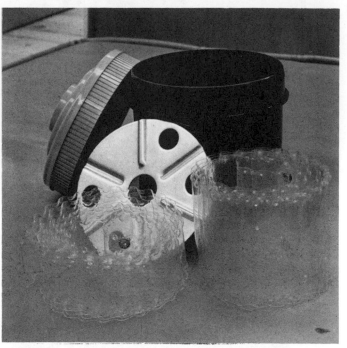

NOTE THE PLASTIC APRONS...... YOU JUST ROLL UP THE FILM IN THE INSIDE OF THE APRON.......

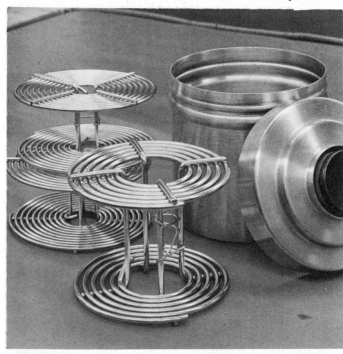

STAINLESS STEEL DEVELOPING TANKS ARE THE MOST USED BY AMATEURS AND PROFESSIONALS!

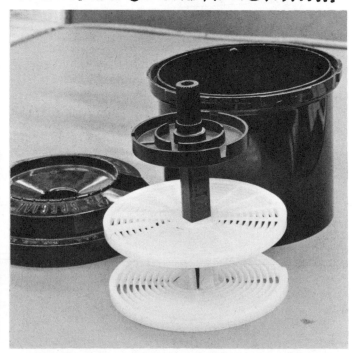

ANOTHER TYPE WHERE THE FILM IS SLID IN...OR YOU CAN LOAD IT FROM THE CENTER-OUT.....

HOW TO DEVELOP FILM!

1. **LOAD FILM INTO DEVELOPING TANK IN DARKNESS!**
 THE LONGER IT TAKES TO LOAD TANK...THE WORSE STATE YOUR FILM WILL BE IN!

2. **TURN WATER ON TO ABOUT 70°**
 DON'T GO OVER 75°

3. **POUR 4 OUNCES OF D-76 IN A TUMBLER AND ADD 4 OUNCES OF WATER....NOW TAKE THE TEMPERATURE OF SOLUTION AND SEE CHART!**
 THE COLDER THE DEVELOPER, THE LONGER THE DEVELOPING TIME!
 IF YOU HAVE 120 FILM, ADD 8 OUNCES OF D-76, AND 8 OUNCES OF WATER!

4. **PLUS-X IN D-76 AT 1:1 AT 70° IS 6½ MINUTES!**
 EACH FILM HAS ITS OWN DEVELOPING TIMES - AND TEMPERATURES.

5. **POUR D-76 INTO TANK AS FAST AS POSSIBLE.... AGITATE IMMEDIATELY FOR 10 SECONDS...TAP TANK AND SET DOWN ON LEVEL SURFACE!**
 IMPORTANT: COUNT POURING TIME AS DEVELOPING TIME!

6. **AGITATE GENTLY FOR 5 SECONDS EVERY 30 SECONDS...NO MORE...NO LESS!**
 TOO MUCH AGITATION WILL BUILD-UP TOO MUCH CONTRAST AND GRAIN!

7. **DUMP DILUTED DEVELOPER DOWN DRAIN AND ADD WATER TWICE AND DUMP!**
 DO NOT RE-USE DILUTED DEVELOPER.... IT'S EXHAUSTED!

8. **ADD HYPO (FIX) FOR 3 MINUTES! AGITATE EVERY MINUTE FOR DURATION!**
 CHECK INSTRUCTIONS ON CAN OR BOTTLE.....

9. **SAVE FIX!**
 CAN BE RE-USED SEVERAL TIMES!

10. **WASH FILM FOR 20 MINUTES IN RUNNING WATER!**
 OR KEEP FILLING AND DUMPING FOR 5 MINUTES

11. **ADD 2 DROPS OF WETTING AGENT, SHAKE-UP UNTIL IT FOAMS, LET SIT FOR ONE MINUTE...POUR WETTING AGENT OVER SPONGE, *WRING OUT AND WIPE!***
 DO NOT WASH FILM AGAIN AFTER WETTING AGENT!

HERE ARE SOME FILM POINTERS!

DECIDE WHAT FILM YOU'RE GOING TO USE AFTER YOU ...GET THERE!

DON'T USE TRI-X FILM OUT IN THE BRIGHT SUNLIGHT!

OVERDEVELOPING IS THE *KISS OF DEATH!*

STICK WITH ONE TYPE OF FILM UNTIL YOU FIGURE IT OUT!

DON'T USE PANATOMIC-X FILM *INSIDE*.. UNLESS YOU'RE DESPERATE!

TREAT YOUR FILM AS IF IT WERE *FLYPAPER!*

FILM

CERTAINLY KODAK IS NOT THE ONLY GOOD BLACK AND WHITE FILM.....THERE ARE OTHERS, INCLUDING GAF, WHICH IS ALSO AN AMERICAN MADE FILM!

HOWEVER, FOREIGN BLACK AND WHITE FILM IS MORE DIFFICULT TO OBTAIN....FOR EXAMPLE, IF YOU WERE ON VACATION AND WERE PASSING THROUGH KNOLLS, UTAH OR LATHROP, MICHIGAN AND YOU STOPPED IN A DRUG STORE TO BUY KODAK OR GAF BLACK AND WHITE FILM, CHANCES ARE THEY WOULD HAVE IT!

BUT TRY AND PURCHASE AGFA ISOPAN, FUJI NEOPAN SSS, OR ILFORD HP3 BLACK AND WHITE FILM AND YOU'LL PROBABLY HAVE TO VISIT SEVERAL CAMERA STORES.....BUT IT'S REALLY WORTH ALL THE TROUBLE!

SINCE KODAK AND GAF BLACK AND WHITE FILM IS JUST ABOUT AVAILABLE EVERYWHERE, WE USE IT!
HOWEVER, COLOR FILM IS AN ENTIRELY DIFFERENT THING!

ALL BLACK AND WHITE FILM, WITH THE EXCEPTION OF SPECIAL TYPES, CAN BE DEVELOPED IN ANY CONVENTIONAL BLACK AND WHITE FILM DEVEL- OPER! ALL YOU NEED TO DO IS FOLLOW THE INSTRUCTIONS PACKAGED WITH THE FILM!

FILM

IF YOU WISH TO TRY OTHER FILM, HERE ARE SOME TYPES I FOUND AVAILABLE.........

FUJI NEOPAN SSS
ASA 200 - JAPAN

AGFA ISS
ASA 100 - GERMANY

IMPERIAL S PAN
ASA 400 - SPAIN

SEARS ROEBUCK
ASA 125 - GERMANY

PRINTS

NO, DUMMY, *PRINTS!* NOT **PRINCE!**

THE PRINT, OR ENLARGMENT OF YOUR PICTURE IS MADE ON A PIECE OF PAPER THAT IS COATED WITH EMULSION IN THE SAME WAY YOUR FILM IS... *BUT NOT AS SENSITIVE!* SINCE THE ENLARGING PAPER IS BLIND TO RED AND A YELLOWISH COLOR, YOU CAN WORK UNDER THOSE COLOR LIGHTS! *HOWEVER.....*THE RECOMMENDED SAFELIGHT IS A *WRATTEN SERIES OC*, WHICH IS SORT OF ORANGISH!

EVERYTHING ON THE NEGATIVE THAT IS BLACK, PRINTS WHITE, AND EVERYTHING THAT'S WHITE, PRINTS BLACK! THE ENLARGER IS A BACKWARD CAMERA....AND LIKE A SLIDE PROJECTOR, WOULD PROJECT COLOR SLIDES IN THE SAME WAY!

PRINTS

HERE ARE FIVE PRINTS OF THE SAME NEGATIVE EXPOSED FROM ONE SECOND TO TWELVE SECONDS TO SHOW YOU THE DIFFERENT DEGREES OF EXPOSURE AND HOW A FEW SECONDS CAN MAKE SO MUCH DIFFERENCE IN HOW THE PICTURE LOOKS!

THE LONGER YOU LEAVE THE PRINT IN THE PAPER DEVELOPER THE DARKER AND MORE CONTRASTY IT WILL BECOME! IT'S BEST TO EXPOSE FOR THE CORRECT TIME AND THEN DEVELOP FOR ABOUT A MINUTE AND A HALF! *YOU HAVE TO PRACTICE!*

ONE SECOND

IT'S WASHED OUT AND THERE ARE NO BLACKS AND AN OVERALL GRAY LOOK! *TERRIBLE!*

THREE SECONDS

GETTING CLOSE! BLACKS ARE COMING IN AND FACE LOOKING BETTER! *KEEP TRYING!*

PRINTS

FIVE SECONDS

ACCEPTABLE, BUT THE FACE IS STILL SORT OF WASHED OUT! SOME WOMEN LIKE THIS KIND!

SEVEN SECONDS

GOOD PRINT! ALL OF THESE WERE LEFT IN THE DEVELOPER FOR EXACTLY 1½ MINUTES!

TWELVE SECONDS

TOO MUDDY! DETAIL LOST IN SHADOW AREAS!

PITCH IT OUT!

PRINTS
HOW TO FIND THE CORRECT EXPOSURE!

30

25

20

15

10

5

LAY A PIECE OF THICK PAPER ACROSS THE EASEL, ALLOWING A STRIP OF EXPOSED ENLARGING PAPER TO SHOW.... STOP THE LENS DOWN 2 STOPS TO MAKE-UP ANY DIFFERENCE IN FOCUSING AND TO AVOID TOO SHORT AN EXPOSURE!

GIVE THE FIRST STRIP 5 SECONDS, THEN MOVE TO THE NEXT STRIP AND GIVE 5 MORE SECONDS! DO THIS FOR THE ENTIRE LENGTH OF THE PHOTO!

NOW ALL YOU DO IS TO PICK THE RIGHT EXPOSURE AND PRINT!

IN THIS CASE I CHOSE THE 20 SECONDS!

YOU'LL SAVE PAPER!

PRINTS
HERE'S THE FINAL PRINT!

WHEN YOU DEVELOP THE TEST PRINT, YOU SIMPLY CHOOSE THE EXPOSURE YOU WANT IN THIS CASE IT WAS THE 20 SECOND EXPOSURE!

STOP THE ENLARGING LENS DOWN TWO STOPS TO CORRECT ANY ERROR IN FOCUSING AND FOR SHORT EXPOSURE TIMES!

DON'T FORGET TO LEAVE THE PRINT IN THE PAPER DEVELOPER FOR THE SAME TIME AS THE TEST PRINT... OTHER-WISE IT DOESN'T MEAN A THING!

REMEMBER: IF THE DEV-ELOPING TIME IS $1\frac{1}{2}$ MIN-UTES, AND IT TAKES 5 SECONDS TO DRAIN OFF THE PAPER DEVELOPER... THAT'S 1 MINUTE AND 25 SECONDS DEVELOPING!

PRINTS

THERE ARE MANY VARIATIONS OF CONTRAST AND EFFECTS THAT ARE CONTROLLABLE IN YOUR FINAL PRINT... NO MATTER WHAT THE NEGATIVE LOOKS LIKE, IF IT'S NORMAL OR OTHERWISE! THE USUAL WAY IS TO PRINT ON GRADED PAPER! THE GRADES ARE FROM 0 TO 6, AND GET MORE CONTRASTY AS THE NUMBERS GET HIGHER! THEY ALSO GET SLOWER AND NEED A LONGER EXPOSURE TIME! THE GENERAL RULE IS, "THE THINNER THE NEGATIVE, THE CONTRASTIER THE PAPER."

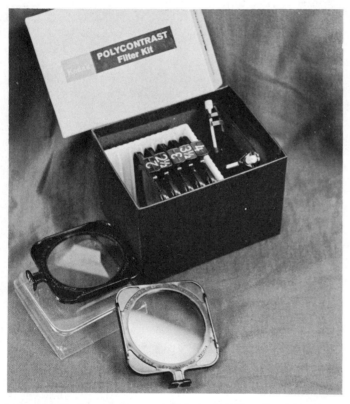

HERE IS A SET OF VARIABLE CONTRAST PRINTING FILTERS AND JUST LIKE THE GRADED PAPERS, THE NUMBER 2 AND 3 ARE CONSIDERED IN THE NORMAL RANGE!

ONE VERY EFFECTIVE METHOD, AND USED BY MANY PROFESSIONAL PHOTOGRAPHERS, IS THE *VARIABLE CONTRAST PRINTING FILTERS!*

YOU SIMPLY HOLD THEM UNDER YOUR ENLARGING LENS DURING EXPOSURE... ... AND *PRESTO* YOU CAN HAVE ANY GRADE OF PAPER YOU DESIRE!

THEY ARE ALSO MADE TO FIT INSIDE OF YOUR ENLARGER, BETWEEN THE LENS AND THE BULB! *NOW YOU CAN HAVE ALL GRADES FOR ONE PRICE!*

HOWEVER... YOU MUST USE *VARIABLE CONTRAST* PAPER WITH THESE FILTERS, BECAUSE ORDINARY ENLARGING PAPER WILL NOT WORK!

PRINTS *POLYCONTRAST FILTER TEST !*

1

1½

2

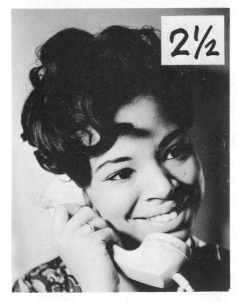

2½

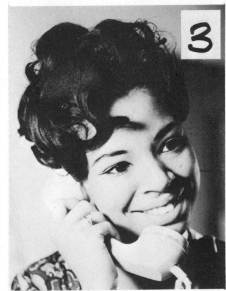

3

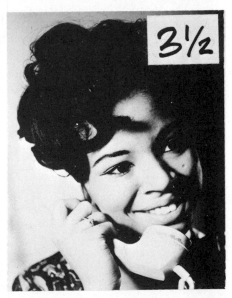

3½

NOTICE, BEGINNING
WITH NO. 2½ FILTER, HOW
CONTRASTY THE PRINTS
BECOME.....UNTIL NO. 4
AND 5 ARE JUST LIKE
DRAWINGS?
NUMBER 5 PAPER WAS
USED BECAUSE THE
FILTERS ONLY GO TO
A NUMBER 4 !
*AGFA MAKES A
NUMBER 6 PAPER !*

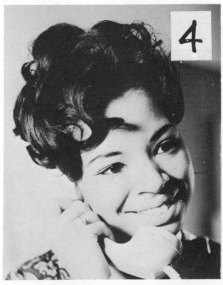

4

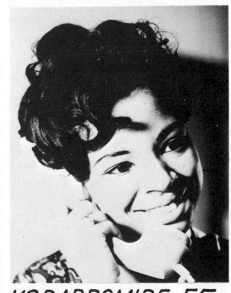

THIS IS DOROTHY *KODABROMIDE F5*

PRINTS *AND GRADED PAPERS!*

THE FOUR PRINTS ARE EXPOSED ON GRADED PAPER!
SINCE YOU HAVE TO STOCK FOUR SEPERATE BOXES, OR EVEN
MORE, IT'S EXPENSIVE COMPARED TO ONE BOX OF FILTERS!

NO. 2 PAPER
A LITTLE MUSHY BUT NOT TOO BAD! *THIS IS MARIA!*

NO. 3 PAPER
MORE CONTRAST... KEEP WATCHING THE EYELASHES!

PRINTS

THE HARDER THE PAPER, THE CONTRASTIER THE PRINT
BECOMES.... AND THE LONGER THE EXPOSURE YOU NEED!
MARIA WAS PHOTOGRAPHED HERE WITH A BRONICA!

NO.4 PAPER
THE CONTRAST IS GETTING
INTERESTING....ISN'T IT?

NO.6 PAPER
THIS IS AGFA PAPER! THE
STUFF IS BEAUTIFUL!

PRINTS
HOW ABOUT GRAIN?

THE LITTLE PRINT OF MARIA, IS EXPOSED ON A NO.3 ENLARGING PAPER....WHICH WAS THE BEST CONTRAST FOR THIS PRINT! NORMALLY, IN A BIG 2¼ NEGATIVE, IT IS VERY DIFFICULT TO GET GRAIN IN YOUR PICTURE...BUT THERE IS A SIMPLE WAY IF YOU WANT TO SWITCH PAPERS!

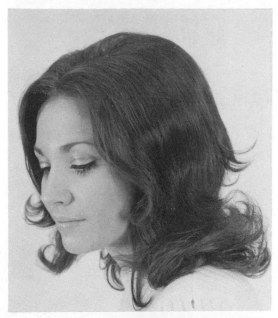

HERE'S THE SAME NEGATIVE PRINTED ON NO.6 AGFA !

IT'S A SECTION FROM AN 11X14 ENLARGEMENT!

NOTICE THE FASCINATING GRAIN STRUCTURE, AND HOW SHARP THE EYELASHES ARE?

AS YOU CAN SEE, THE POSSIBILITIES WITH THIS PAPER ARE ALMOST UNLIMITED!

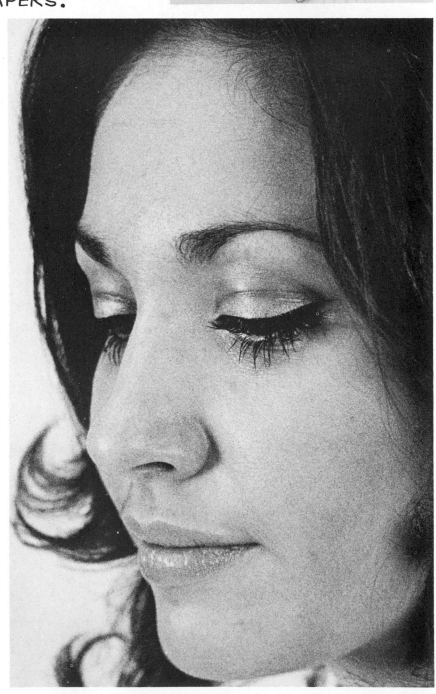

PRINTS
THE CONTACT PRINT!

THE CONTACT PRINT.... OR SOMETIMES CALLED "GANG-PRINTING", IS A CONVENIENT WAY TO SEE ALL OF YOUR NEGATIVES IN PRINT, ACTUAL SIZE.... AT THE SAME TIME!

THIS IS A CONTACT PRINTER! IT IS JUST A HINGED PIECE OF THICK GLASS OVER A FRAME WITH SPONGE ON IT TO CUSHION THE GLASS FOR A GOOD CONTACT DURING EXPOSURE!

YOU COULD USE A PIECE OF ORDINARY GLASS, WITH THE EDGES ROUNDED SO YOU WON'T CUT YOURSELF!

THEN YOU PUT THE NEGATIVES ON TOP OF THE ENLARGING PAPER IN THE CONTACT PRINTER, AND FOLD THE GLASS OVER ON IT!

STOP THE LENS DOWN 2 STOPS AND GIVE IT 5 SECONDS FOR A STARTER! *(ASSUMING YOU HAVE NORMAL NEGATIVE!)*

AND ANOTHER THING.... YOU CAN PUT YOUR NEGATIVES IN A NEGATIVE SLEEVE AND TAPE THEM ON THE BACK OF YOUR CONTACT PRINTS FOR FILING AWAY!

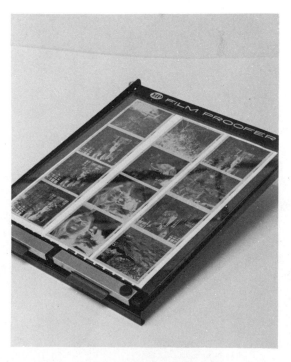

USE ORDINARY ENLARGING PAPER!

PRINTS

HERE IS A CONTACT PRINT!

PRINTS CLOSE-UPS, *THE EASY WAY!*

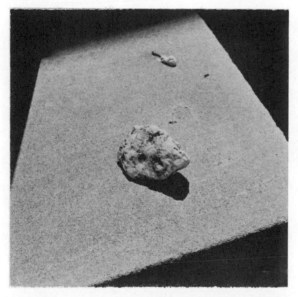

THIS IS ONE PIECE OF CRUSHED ROCK...TAKEN WITH A MIRANDA 35mm SLR CAMERA...USING A MEDIUM SPEED BLACK AND WHITE FILM FROM SEARS!
THIS IS AS CLOSE AS THE NORMAL 50mm LENS WOULD ALLOW.... *ABOUT 18 INCHES THESE ARE ALL 4X5 PRINTS!*

NEXT.... I PURCHASED AN ORDINARY MAGNIFYING GLASS...WHICH COSTS ME ABOUT $ 1.78.... AND I PUT IT OVER THE CAMERA LENS... AND TOOK THE PICTURE AGAIN *SAME F-STOP AND SHUTTER SPEED ...f8 at 1/125*

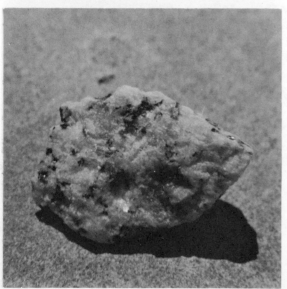

....AND GOT THIS!

NEED I SAY ANY MORE?

CHECK THE NEXT PAGE FOR SOME MORE EXAMPLES!

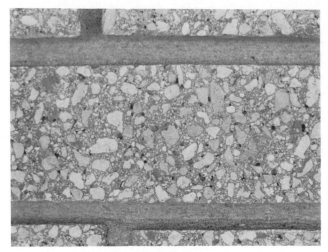

A BRICK

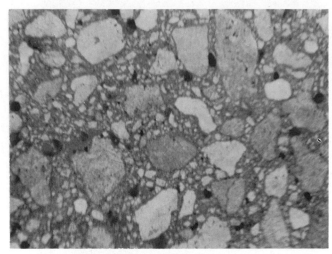

THE CLOSE-UP

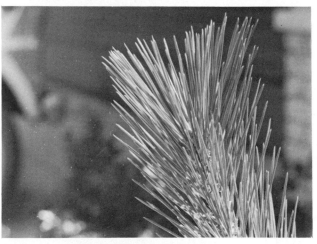

BLACK PINE

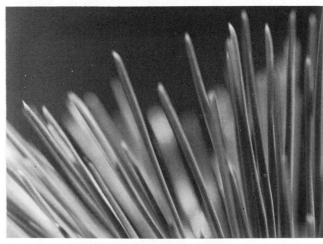

THE CLOSE-UP

JUNIPER BUSH

THE CLOSE-UP

PRINTS *RETICULATION!*

RETICULATION IS WHEN THE EMULSION IS WRINKLED AND INDENTED, AND LOOKS LIKE LEATHER... AS YOU CAN SEE IN THIS PICTURE! IT'S A FACINATING EFFECT THAT CAN ADD IMPACT TO YOUR COMPOSITION... BUT IT IS NOT THAT EASY TO OBTAIN, AND IS UNPREDICTABLE!

HERE'S THE SECRET:

WARM DEVELOPER AND WARM FIXING BATH..... FOLLOWED BY VERY COLD WASH WATER!

TRY IT THIS WAY AS A STARTER: DEVELOP YOUR FILM IN DEVELOPER THAT IS 75 OR 80 DEGREES..... THEN WASH THE FILM WITH WATER OR STOP BATH AT THE SAME TEMPERATURE... FOLLOWED BY FIX, ALSO AT THE SAME TEMPERATURE!
NOW... TURN ON THE COLD WASH WATER.... AS COLD AS YOU CAN GET, FOR ABOUT 10 MINUTES!

THIS TECHNIQUE, LIKE ANY TECHNIQUE, SHOULD NOT BE OVERDONE... AND ABOVE ALL BE SELECTIVE ABOUT THE SUBJECT MATTER!

PRINTS

HERE'S A SECTION FROM A 16X20 PRINT OF THE SAME NEGATIVE.......AS YOU CAN SEE, IT LOSES ITS APPEAL WHEN THE ENLARGEMENT IS TOO GREAT!

DON'T BE SURPRISED IF IT DOESN'T WORK THE FIRST TIME YOU TRY IT! I'VE FOUND THE MOST SUCCESS WITH THE SLOW PANATOMIC-X FILM!

HERE'S WHAT I DO:

I PUT ICE CUBES IN MY TANK AND MAKE ICE WATER...THEN I SOAK MY FILM IN THAT AS SOON AS IT COMES OUT OF THE FIX.... *IF THAT DOESN'T WORK...NOTHING WILL!*

THE BEST SUBJECT MATTER FOR THE RETICULATION TECHNIQUE IS PEOPLE! STILL LIFE IS ALMOST AS EFFECTIVE! *STICK WITH ONLY 8X10 PRINTS!*

PRINTS *HOW THEY ARE DEVELOPED!*

1 . CLEAN NEGATIVE WITH CAMEL HAIR BRUSH, STATIC MASTER, OR RUN BETWEEN TWO FINGERS TO GET OFF DUST AND HAIRS!

2 . PUT NEGATIVE IN NEGATIVE CARRIER! SHINY-SIDE UP....... THAT'S EMULSION TO EMULSION... AND UP-SIDE-DOWN!

3 . TURN ON ENLARGER LIGHT AND OPEN LENS TO ITS BRIGHTEST!

4 . MOVE LAMPHOUSE UP OR DOWN FOR DESIRED PRINT SIZE!

5 . FOCUS WITH FOCUSING KNOB UNTIL PICTURE IS SHARP!

6 . STOP THE LENS DOWN TWO CLICKS...OR STOPS!

7 . TURN OFF ENLARGER!

8 . PUT SHEET OF ENLARGING PAPER IN EASEL ... EMULSION TO EMULSION... *(SHINY-SIDE UP)*

9 . TURN ENLARGER BACK ON FOR ABOUT 10 SECONDS AS A STARTING POINT, OR USE TEST EXPOSURE SHEET!

10 . SLIDE EXPOSED PAPER INTO DEVELOPING TRAY, FACE DOWN, PUSHING CENTER AND CORNERS DOWN WITH PRONGS TO GET OUT TRAPPED AIR BUBBLES! *ROCK TRAY!*

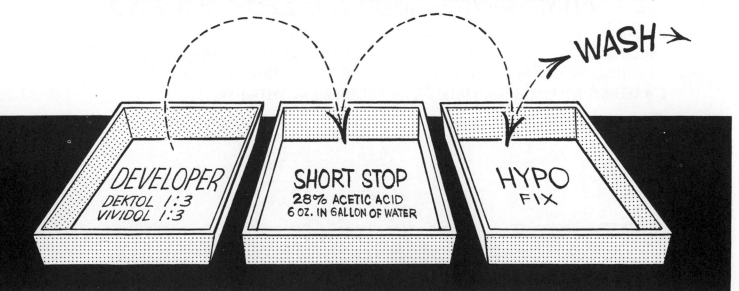

PRINTS

11 . AFTER ABOUT 20 SECONDS, TURN PAPER OVER KEEP ROCKING TRAY! DO NOT TAKE PRINT OUT OF DEVELOPER DURING DEVELOPING TO EXAMINE IT!

12 . KODAK SAYS TO DEVELOP ONE MINUTE ... BUT YOU'LL FIND 1½ MINUTES IS BETTER FOR RICHER PRINTS!

13 . NOW PICK IT UP AND LET IT DRAIN ... AND COUNT THIS DRAIN TIME AS DEVELOPING TIME ... *DON'T FORGET!*

14 . PUT PRINT IN SHORT-STOP, OR WATER, FOR ABOUT 15 SECONDS ... *AND AGITATE!*

15 . PICK UP AND DRAIN ... *NO NEED TO COUNT DRAIN TIME!*

16 . PUT PRINT IN FIX (HYPO) ... FACE DOWN .. AND AGITATE!

17 . AFTER IT HAS BEEN IN FIX FOR ABOUT 20 SECONDS, YOU CAN INSPECT IT WITH A FLASHLIGHT ... BE SURE PRINT IS SUBMERGED BEFORE TURNING ON LIGHT! *NOTE: YOU CAN'T TURN ON ROOM LIGHT DURING CLASS SESSION, AS YOU WILL FOG OTHER STUDENTS' WORK!*

18 . LEAVE IN HYPO ABOUT 5 MINUTES! EVERY SO OFTEN ROCK THE TRAY!
WASH PRINTS FOR 20 MINUTES IN A ROTARY WASHER, OR 45 MINUTES IN RUNNING AND MOVING WATER INTO A DISH OR TRAY! INSUFFICIENT WASHING WILL CONTAMINATE DRYING EQUIPMENT WITH HYPO!

PRINTS

IT'S IMPORTANT TO USE THE PROPER DARKROOM TOOLS, BUT IN AN EMERGENCY..... TRY THESE:

SAFELIGHTS
A DESK LAMP WITH A LOW-WATTAGE BULB, AND COVERED WITH RED CELLOPHANE!OR A SINGLE CANDLE AT 4 FEET!

TRAYS
ANY DEEP DISH OR PLATE, AS LONG AS THEY ARE NON-METALLIC!

PRINTING EASEL
BESIDES A PIECE OF GLASS FOR CONTACT PRINTS, YOU CAN USE A PIECE OF BOARD OR MASONITE, AND PUT DOWN DOUBLE-SIDED TAPE TO HOLD PAPER!

FILM CLIPS
ANY KIND OF SPRING-TYPE CLOTHESPIN WORKS FINE!

HERE ARE SOME POINTERS ON MAKING PRINTS!

YEH!

DON'T GO BACK TO THE DEVELOPER AFTER THE FIX... IT'S TOO LATE, AND IT WON'T WORK!

USE A FOCUSING AID...... SUCH AS A BAUSH AND LOMB, AN ACCURA, OR A SCOPONET! THERE ARE OTHER BRANDS TOO!

DON'T WASTE YOUR TIME AND PAPER ON THIN UNDEREXPOSED NEGATIVES

DON'T USE YOUR HANDS, USE YOUR PRINT TONGS

FOCUS WITH THE LENS WIDE OPEN!

DON'T FORGET TO DRAIN PICTURES AFTER EACH STEP!

DON'T TRY TO READ UP SIDE DOWN SIGNS

IF YOU DON'T WASH YOUR PRINTS, THEY WILL EVENTUALLY TURN BROWN!

KEEP MOVING PRINTS AROUND IN DEVELOPER OR ROCK THE TRAY! DON'T LET 'EM COOK

DON'T RUB YOUR FINGERS ON PRINT IN DEVELOPER...IT WON'T DO ANYTHING BUT RUPTURE THE EMULSION

DON'T TAKE PRINT OUT OF DEVELOPER TO LOOK AT IT BEFORE DEVELOPING IS OVER

82

83

DEVELOPERS

WHAT'S IN A FILM AND PAPER DEVELOPER?

A DEVELOPER TURNS THE INVISIBLE LATENT IMAGE THAT WAS FORMED DURING EXPOSURE, INTO A VISIBLE PICTURE! IT DOES THIS BY CHANGING THE SILVER SALT COMPOUNDS INTO METALLIC SILVER – *SORRY... I HAD TO DO THAT!*

HERE'S WHAT'S IN IT:

DEVELOPING AGENT: *METOL AND HYDROQUINONE*

THIS IS THE WORKER THAT CONVERTS THE SILVER COMPOUNDS INTO A SILVER IMAGE! SOME DEVELOPERS USE MORE THAN ONE OF THIS AGENT!

A PRESERVATIVE: *SODIUM SULFITE*

IT HAS ONE IMPORTANT JOB... IT STOPS THE DEVELOPER FROM GOING BAD TOO RAPIDLY!

AN ALKALI: SODIUM CARBONATE

MOST OF THE DEVELOPING AGENTS WILL ONLY WORK IN AN ALKALI SOLUTION! *ALSO CALLED AN "ACTIVATOR"*

A RESTRAINER: *POTASSIUM BROMIDE*

THIS IS USUALLY INCLUDED TO REDUCE THE FOG NORMALLY PRESENT DURING DEVELOPING!

DEVELOPERS

QUICK!
I NEED
A
FIX!
WHAT'S
IN A
FIX?

FIXING BATH:
USUALLY SODIUM THIOSULFATE-
THIS DISSOLVES THE UNEXPOSED
AND UNDEVELOPED SILVER...IT'S
CALLED HYPO!

PRESERVATIVE:
SODIUM SULFITE - STOPS HYPO
FROM BEING DECOMPOSED BY
THE ACID!

ACID:
ACETIC ACID, WHICH STOPS THE
DEVELOPMENT AND ALLOWS THE
HARDENER TO WORK!

HARDENER:
POTASSIUM ALUM-HARDENS THE
EMULSION!

BUFFER:
BORIC ACID, WHICH
STOPS SLUDGE!

DEVELOPE

DEVELOPERS

DIAFINE

THIS HAS TWO SOLUTIONS USED IN SUCCESSION! TIME IS THE SAME FOR ALL FILM: 2-3 MIN. FOR 35mm, AND 3-4 MIN. FOR ROLL FILM! GIVES ONE STOP MORE FILM SPEED THAN FILM MAKER RECOMMENDS! MODERATE CONTRAST, EXCELLENT SHARPNESS, MEDIUM FINE TO FINE GRAIN! *AGITATION CHANGES RESULTS!*

EDWAL FG7

OF ALL DEVELOPERS, THIS IS THE MOST VERSTILE! CAN BE USED IN VARIOUS DILUTIONS! GOOD COMBINATION IS 1+15 WATER! EXCELLENT SHARPNESS, MEDIUM TO VERY FINE GRAIN, AND ONE FULL STOP MORE THAN MAKER'S RECOMMENDATION! *KEEPS BETTER THAN ALL OTHER FILM DEVELOPERS!*

EDWAL MINICOL

VERY, VERY SOFT WORKING! USED DILUTED AS A SINGLE SHOT WITH PANATOMIC-X, OR EVEN PLUS-X, GIVES GOOD SHARPNESS AND ABOVE AVERAGE GRAININESS... ALSO GIVES MODERATE FILM SPEED!
. *GOOD DEVELOPER FOR PORTRAITS!*

DEVELOPERS

ETHOL UFG

POWERFUL AND VERY OUTSTANDING SOFT WORKING WITH MODERATE CONTRAST! FINE TO MEDIUM-FINE GRAIN AND EXCELLENT SHARPNESS! GIVES ONE FULL STOP OVER THE FILM MAKER'S RECOMMENDED RATING! KEEPS PRETTY WELL, BUT WATCH OUT FOR CONTAMINATION!

FR X-22

THIS IS ANOTHER SINGLE SHOT DEVELOPER FOR THE VERY THIN EMULSION FILMS, LIKE PANATOMIC-X, OR AGFA ISOPAN F! IT'S A LIQUID AND HAS LOW GRAIN AND EXTREMLY HIGH IN SHARPNESS AND HIGH FILM SPEED! FR X-22 KEEPS WELL..... BUT AIR RUINS IT VERY QUICKLY!

ILFORD MICROPHEN

SOFT WORKING AND POWERFUL! THIS DEVELOPER WILL GIVE YOU VERY HIGH FILM SPEEDS, MEDIUM FINE GRAIN WITH MODERATE CONTRAST AND EXCELLENT SHARPNESS! MICROPHEN KEEPS WELL, AND COMES IN A POWDER FORM! IT WORKS WITH ALL FILM, EXCEPT KODAK ROYAL-X PAN ROLL!

DEVELOPERS

ACUFINE

POWERFUL SOFT-WORKING DEVELOPER, GIVING OUTSTANDING GENERAL PURPOSE COMBINATION OF VERY HIGH FILM SPEED... FROM ONE TO TWO EXTRA STOPS FROM FILM MAKER'S RECOMMENDED RATING! EXCELLENT SHARPNESS, MEDIUM TO FINE GRAIN, AND A MODERATE CONTRAST! *EASILY CONTAMINATED! KEEPS WELL!*

AGFA RODINAL

POWERFUL LIQUID CONCENTRATE USED AS SINGLE-SHOT AND AT EXTREME DILUTION! NOT FINE GRAIN, BUT GRAIN IS TIGHT AND RAZOR EDGED! IMAGE IS VERY, VERY SHARP! KEEPS WELL, BUT AVOID CONTACT WITH SKIN! MOST DILUTION COMBINATIONS ARE: 1+25, 1+50 1+75, AND 1+100! *NEGATIVES LOOK BEAUTIFUL!*

GAF HYFINOL

A GOOD ENERGETIC DEVELOPER THAT IS MODERATE AND SOFT WORKING, AND A GOOD GENERAL PURPOSE FORMULA! IT HAS MEDIUM FINE GRAIN, AND MODERATE CONTRAST! IT'S A GOOD DEVELOPER FOR HIGH FILM SPEEDS, AND KEEPS WELL! COMES IN POWDER FORM!

CLAYTON P-60

CONTAINS PHENIDONE, WHICH MAKES IT VERSATILE, SOFT WORKING.. AND VERY POWERFUL... PLUS VERY HIGH FILM SPEEDS! THE GRAIN IS MEDIUM-FINE TO FINE! IT'S A GREAT DEVELOPER FOR PUSHING FILM SPEEDS, AND THE NEGATIVES ARE SOMETHING TO BEHOLD! *KEEPS FAIRLY WELL!*

DEVELOPERS

KODAK MICRODOL-X

SOFT WORKING, VERY FINE GRAIN, MODERATE FILM SPEED, AND GOOD SHARPNESS! STORAGE LIFE IS LESS THAN D-76! WHEN THIS DEVELOPER IS DILUTED 1+3, THERE IS A SMALL NOTICABLE INCREASE IN FILM SPEED... AND A LITTLE MORE GRAININESS! *COMES IN POWDER FORM!*

MAY & BAKER PROMICROL

VERY POWERFUL AND SOFT WORKING, AND GIVES ABOUT A FULL STOP MORE THAN MAKER'S RECOMMENDED RATING! IT IS A MEDIUM FINE GRAIN AND MODERATE CONTRAST.. AND VERY POOR SHARPNESS! GOOD DEVELOPER FOR HIGH FILM SPEED WHEN FINE DETAIL IS UNIMPORTANT! *COMES IN POWDER!*

ETHOL TEC

SINGLE-SHOT DEVELOPER FOR SLOW AND MEDIUM SPEED HIGH-SHARPNESS FILMS! IT GIVES MODERATE FILM SPEED AND HIGH SHARPNESS! COMES IN LIQUID FORM AND KEEPS VERY WELL! *ETHOL TEC HAS A LONG STORAGE LIFE UNDILUTED!*

I'LL TURN THE LIGHTS OUT WHILE YOU LOAD YOUR FILM IN YOUR DEVELOPING TANKS!!!

NOW, ALL THOSE WHO HAVE THEIR FILM LOADED IN THEIR TANKS, RAISE THEIR HANDS!

DEVELOPERS

KODAK D-76

OUTSTANDING, VERSATILE, POWERFUL, BUT SOFT-WORKING DEVELOPER! GIVES HIGH SPEED, MODERATE CONTRAST, FINE-TO MEDIUM-FINE GRAIN, AND EXCELLENT SHARPNESS! USED DILUTED 1+1, IT'S A GOOD SINGLE-SHOT! VERY LONG STORAGE LIFE! *MANY PROFESSIONALS USE THIS DEVELOPER!*

KODAK DK-50 & GAF ISODOL

TWO GOOD ENERGETIC NON-FINE GRAIN DEVELOPERS, WHICH WHEN DILUTED, MAKE SINGLE-SHOT, GOOD SHARP NEGATIVES! HAS MODERATE CONTRAST! ISODOL WILL GIVE A LITTLE HIGHER CONTRAST THAN DK-50 IN THE SAME TIME! *USE ISODOL FOR GAF FILM, AND DK-50 FOR KODAK FILM!*

KODAK HC-110

VERY HIGHLY CONCENTRATED... DILUTES TO A POWERFUL, SHARP AND VERY FAST WORKING MEDIUM FINE GRAIN DEVELOPER, WITH MODERATE CONTRAST! ONE BOTTLE OF THIS DYNAMITE WILL MAKE 2 GALLONS OF 1+15 WORKING SOLUTION! *HC-110 HAS A VERY, VERY LONG LIFE! (UNDILUTED)*

ACCIDENT POINT 3500 ft.
EVERY YEAR 307 PERSONS LOSE THEIR LIVES WHILE TAKING PICTURES OF THIS ROCK!

DEVELOPERS
LET'S SEE WHAT DEVELOPERS DO.......

BELOW IS A SECTION OF A 5X7 PRINT OF A JUNK PILE,
TAKEN WITH A MIRANDA 35mm SLR CAMERA, USING
THE NORMAL LENS....ON A TRIPOD, WITH PLUS-X
FILM, AND A CABLE RELEASE! f8 AT 1/250
NOTICE HOW NICE AND SHARP IT IS ?

THIS IS THE RODINAL DEVELOPED PRINT, WHICH YOU CAN COMPARE
WITH THE BIG 16X20 BLOW-UP ON THE NEXT PAGE!

UNLESS YOU MAKE 11X14 OR 16X20 PRINTS
ALL THE TIME, YOU'RE NOT GOING TO SEE
MUCH DIFFERENCE IN YOUR 8X10 PRINTS
BETWEEN DEVELOPER COMBINATIONS!

HOWEVER, IF YOU'RE GOING TO PUSH YOUR FILM A STOP OR
TWO, THEN YOU'LL SEE THE DIFFERENCE IN GRAIN AND
SHARPNESS IN 8X10 PRINTS....YOU'LL SEE PLENTY!

DEVELOPERS

STUDY THESE FOUR FILM DEVELOPERS FOR PLUS-X FILM, BLOWN-UP TO A SECTION OF A 16X20 PRINT!

MICRODOL-X, 1+3

THREE PARTS WATER AND ONE PART DEVELOPER! THIS HAS THE FINEST GRAIN OF ALL FOUR, AND HAS GOOD SHARPNESS *A GOOD COMBINATION!*

D-76, 1+1

GOOD CONTRAST AND FINE GRAIN, PLUS IT HAS EXCELLENT SHARPNESS!

THIS IS ONE DEVELOPER THAT'S NICE HAVING AROUND

ACUFINE, 1+1

VERY SHARP GRAIN AND EXCELLENT SHARPNESS!

HERE'S ANOTHER GOOD ONE TO HAVE AROUND FOR HIGH FILM SPEED!

RODONAL, 1+75

GRAIN IS TERRIBLE, BUT IT'S THE SHARPEST OF ALL FOUR COMBINATIONS!

JUST STAY AWAY FROM THOSE BIG BLOW-UPS!

DEVELOPERS ACUFINE

WHEN DEVELOPING 1:1, DOUBLE DEVELOPING TIMES! AGITATE 5 SECONDS EVERY MINUTE!

	ACUFINE EXPOSURE INDEX*	DEVELOPING TIME AT					
		65°	68°	70"	75°	80°	85° F
35mm FILMS							
Kodak Tri-X	1200	6	5¼	4¼	3¾	3	2¼
Kodak Plus-X	320	5	4½	4	3¼	2½	2
Kodak Panatomic-X	100	2½	2¼	2	1¾	1¼	1
Kodak 2475 Recording	3200	8¾	7¾	7	5½	4½	3½
Ilford FP-4	200	5	4½	4	3¼	2½	2
Ilford HP4	1600	10	8¾	8	6¼	5	4
Ilford Pan-F	64	2½	2¼	2	1¾	1¼	1
Agfa Agfapan 100	320	8¾	7¾	7	5½	4½	3½
Agfa Agfapan 400	800	8¾	7¾	7	5½	4½	3½
Agfa Isopan Record	1000	8¾	7¾	7	5½	4½	3½
Agfa Isopan F	125	3¾	3¼	3	2¼	1¾	1½
Agfa Isopan FF	64	2½	2¼	2	1¾	1¼	1
Adox KB-21	250	3¾	3¼	3	2¼	1¾	1½
Adox KB-17	160	3¼	2¾	2½	2	1¾	1¼
Adox KB-14	64	2½	2¼	2	1¾	1¼	1
Ansco Super Hypan	1000	8¾	7¾	7	5½	4½	3½
Ansco Versapan	250	4¾	4¼	3¼	3	2¼	1¾
120/620/127 FILMS							
Kodak Tri-X Professional	800	7½	6½	6	4¾	3¾	3
Kodak Tri-X	1200	7½	6½	6	4¾	3¾	3
Kodak Plus-X	320	5	4½	4	3¼	2½	2
Kodak Verichrome Pan	250	5¾	5	4½	3½	2¾	2¼
Kodak Panatomic-X	100	5¾	5	4½	3½	2¾	2¼
Ilford HP4	1600	12½	11	10	8	6½	5
Ilford FP-4	200	7½	6½	6	4¾	3¾	3
Agfa Pro 100	320	12½	11	10	8	6½	5
Agfa Pro 400	800	12½	11	10	8	6½	5
Agfa Isopan Record	1000	8¾	7¾	7	5½	4½	3½
Agfa Isopan F	125	4¼	3¾	3½	2¾	2¼	1¾
Agfa Isopan FF	64	3¾	3¼	3	2¼	1¾	1½
Adox R-21	250	5	4½	4	3¼	2½	2
Adox R-17	160	3¾	3¼	3	2¼	1¾	1½
Adox R-14	64	3¼	2¾	2½	2	1¾	1¼
Ansco Super Hypan	1000	10	8¾	8	6¼	5	4
Ansco Versapan	250	7½	6½	6	4¾	3¾	3
SHEET FILMS							
Kodak Tri-X	800	6¼	5½	5	4	3¼	2½
Kodak Plus-X Pan	320	10	8¾	8	6¼	5	4
Kodak Panatomic-X	80	6¼	5½	5	4	3¼	2½
Kodak Tri-X PACK	800	10	8¾	8	6¼	5	4
Kodak Super-XX	500	12½	11	10	8	6½	5
Kodak LS Pan	100	5¾	5	4½	3½	2¾	2¼
Kodak Royal-X Pan	3000	15	13	12	9½	7½	6
Kodak Royal Pan	1000	10	8¾	8	6¼	5	4
Kodak Super Panchro Press B	320	10	8¾	8	6¼	5	4

REPRODUCED BY PERMISSION OF ACUFINE CORP., 439-447 EAST ILLINOIS ST., CHICAGO, ILL. 60611

FILTERS

FORGET ABOUT ALL THOSE CHARTS AND DIAGRAMS YOU'VE SEEN ON FILTERS FOR JUST A MINUTE AND LOOK AT IT A NEW WAY!

A GREEN FILTER OVER YOUR CAMERA LENS WILL MAKE EVERYTHING IN THE PICTURE THAT IS GREEN LOOK *LIGHTER!*

SUCH AS GRASS.....

A BLUE FILTER WILL LIGHTEN UP THE BLUE SKY... OR EVEN TURN IT WHITE... AND A RED FILTER WILL LIGHTEN UP A RED FLOWER OR TURN IT WHITE!

DON'T FORGET THAT RULE!

FILTERS

MOST PEOPLE THINK OF *FILTER* AS A DEVICE FOR LIQUID TO PASS THROUGH LEAVING AN UNWANTED SUBSTANCE BEHIND.... LIKE AN OIL FILTER IN A CAR..... OR A SIEVE! WELL, PHOTO FILTERS ACT THE SAME WAY..... *EXCEPT THEY FILTER LIGHT!*

REMEMBER.... THINGS LOOK DIFFERENTLY ON FILM THAN THEY LOOK TO THE HUMAN EYE! FOR EXAMPLE..... A DEEP BLUE SKY WITH WHITE CHALKY CLOUDS LOOKS BEAUTIFUL, BUT IN AN ORDINARY PICTURE THE SKY WON'T BE AS DARK OR THE CLOUDS AS WHITE! THAT'S BECAUSE ALL FILM IS ESPECIALLY SENSITIVE TO BLUE LIGHT, AND EVEN MORE TO ULTRAVIOLET.... WHICH IS *INVISIBLE RADIATION...* BOTH ARE IN ABUNDANCE IN THE SKY!

BUT TO THE FILM, THE SKY LOOKS MUCH NEARER THE BRIGHTNESS OF THE CLOUDS THAN IT LOOKS TO YOU!

A FILTER DIMS ALL THE BRIGHTNESS REACHING THE FILM AND MAKING IT NECESSARY TO INCREASE THE SIZE OF THE HOLE TO LET IN MORE LIGHT..... THAT'S CALLED *FACTOR!*

NOTE:

COLOR FILMS USUALLY DON'T NEED FILTERING.... AND THE ONES THAT ARE USED ARE OF A DIFFERENT BREED!

FILTERS

MOST 35mm SLR CAMERAS HAVE A BUILT-IN LIGHT METER THAT IS SEEN IN THE VIEW-FINDER.... AND IT LOOKS LIKE THIS WHEN YOU HAVE THE RIGHT SHUTTER SPEED AND f STOP!
NOTICE THE NEEDLE IN CENTER!

NOW... PUT ON A RED FILTER AND LOOK WHAT HAPPENS!!! SINCE THE FILTER HAS DIMMED THE LIGHT COMING INTO THE CAMERA, IT'S NO LONGER THE CORRECT EXPOSURE AND THE NEEDLE DROPS FROM CENTER!

SO....YOU OPEN UP THE HOLE IN THE CAMERA *TWO STOPS*..AND PRESTO...EVERYTHING'S BACK THE WAY IT WAS!
OF COURSE, YOU COULD HAVE GONE FOR A SLOWER SHUTTER SPEED INSTEAD... BUT THAT'S YOUR CHOICE!

WHAT I'M SAYING IS THIS: YOU'RE USING THE FILTER FACTOR CORRECTLY BECAUSE YOUR BUILT-IN METER IS DOING IT *FOR YOU!*

IF YOUR METER IS NOT BUILT-IN..YOU MUST DO DIFFERENTLY!

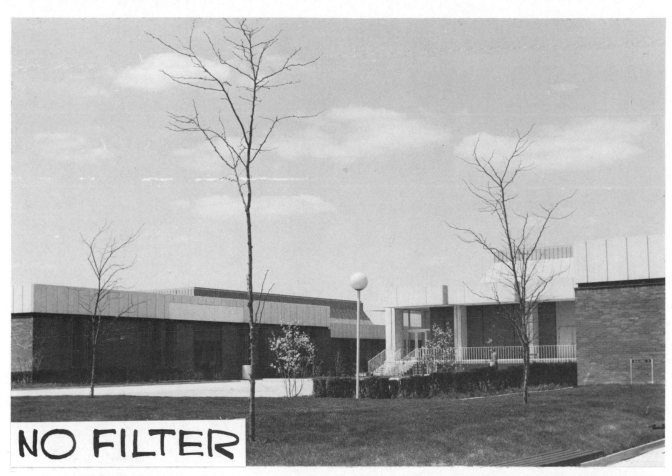

NO FILTER

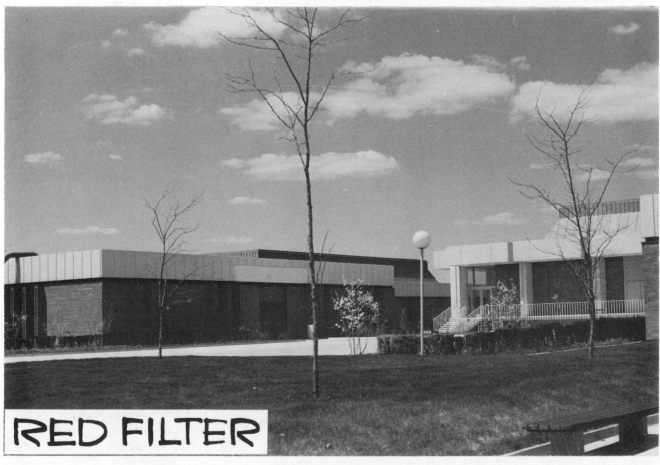

RED FILTER

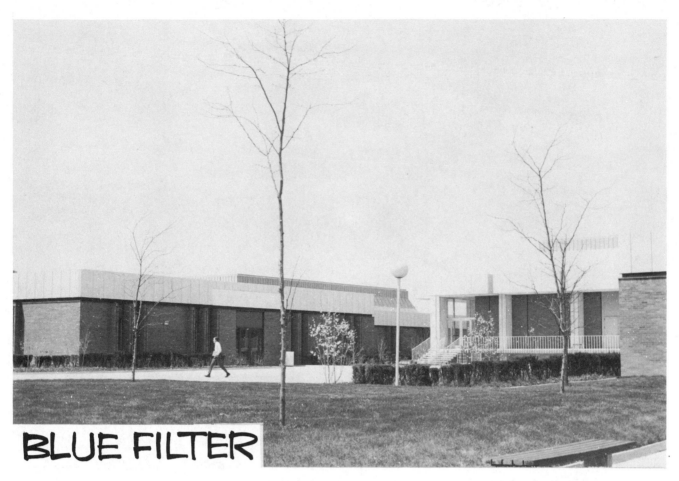

BLUE FILTER

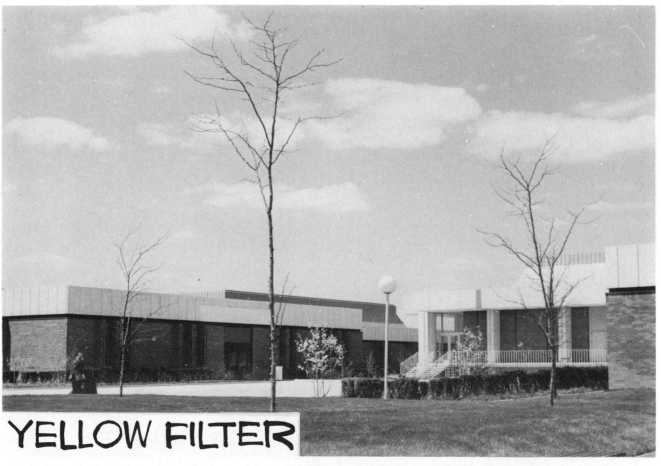

YELLOW FILTER

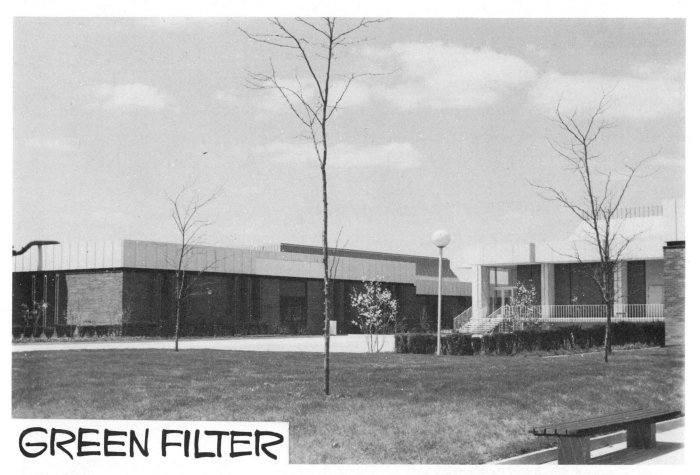

GREEN FILTER

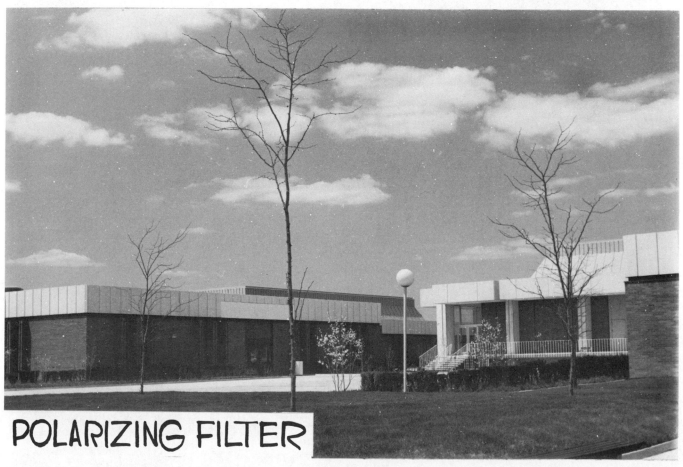

POLARIZING FILTER

FILTERS

YOU'LL NOTICE IN THIS PRINT HOW DARK THE SKY IS AND HOW WHITE THE CLOUDS ARE ... AND ALSO THE BUILDINGS ARE ON THE DARK SIDE!
ORDINARILY, YOU WOULDN'T PUT A POLARIZING FILTER OVER A RED ONE BECAUSE YOU'D LOSE TOO MANY STOPS ... **LIKE THREE!**
YOU SEE, THE RED FILTER HAS A **X4** FACTOR AND THE POLARIZING FILTER HAS A **X2** FACTOR ... THAT'S **THREE STOPS!**
THE ORIGINAL PICTURE WITHOUT A FILTER WAS SHOT AT 1/500 SEC. AT f16 ... AND NOW IT'S 1/500 SEC. AT f5.6 *OF COURSE THAT WOULDN'T BE A PROBLEM ON A SUNNY DAY... AND YOU WOULDN'T NEED A TRIPOD!*

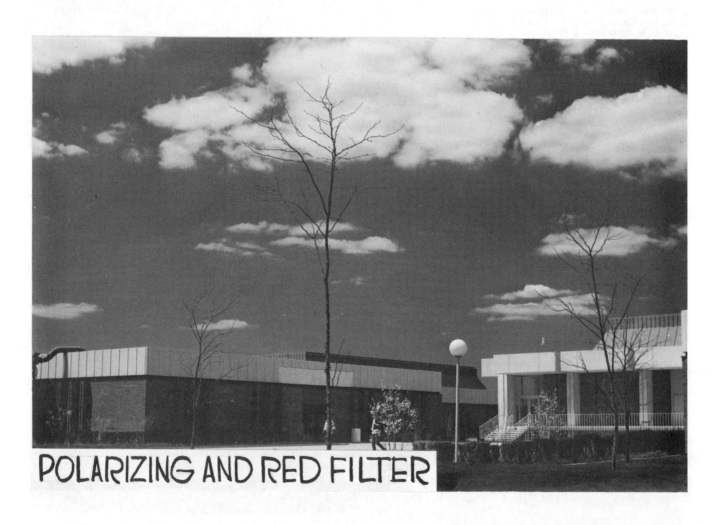

POLARIZING AND RED FILTER

FILTERS

FILTERS ARE SOLD IN SERIES...
SUCH AS SERIES V, VI, VII, VIII,
ETC.,ETC., AND IN MILLIMETERS!
YOUR CAMERA HAS A CERTAIN
SIZE...SO CHECK AT A CAMERA
STORE! THEY USUALLY ARE IN
THIS ORDER: 27mm, 29.5mm,
40.5mm,43mm,46mm,49mm,
52mm,55mm,58mm,62mm,
67mm,72mm, AND 77mm!

THESE FILTERS ARE FOR A MIRANDA.....AS PICTURED!
THEY ARE 46mm IN DIAMETER AND SCREW ON THE
FRONT OF THE LENSE! *ALL FILTERS SCREW ON!*

FILTERS

ANOTHER EXAMPLE OF THE POLARIZING FILTER....
YOU WOULD HAVE A TOUGH TIME SEEING SOME-
ONE SITTING IN THE CAR WITH ALL THAT GLARE
AND REFLECTION... AND NOTICE HOW EVERY-
THING IN THE PICTURE IS DARKENED! USING
THIS FILTER WITH COLOR SLIDES MAKES ALL
THE COLORS LOOK RICHER... AND SKIES BLUER!

NO **FILTER** WHO NEEDS GLARE

POLARIZING FILTER ISN'T THIS BETTER?

FILTERS

USUALLY, POLARIZING FILTERS COST MORE THAN THE OTHER KINDS, BUT ARE WORTH THE EXTRA COST AS THEY WORK WITH COLOR FILM AND BLACK AND WHITE BOTH! YOU'RE FAMILIAR WITH POLAROID SUN GLASSES, AND HOW THEY CUT DOWN GLARE AND REFLECTIONS IN THE BRIGHT SUN...WELL, THE POLARIZING FILTER DOES THE SAME THING ON YOUR CAMERA!
AFTER THEY'RE PUT OVER YOUR CAMERA LENS, THEY TURN LIKE A LITTLE WHEEL.... ALL YOU DO IS WATCH THROUGH YOUR VIEWFINDER AND TURN THE FILTER UNTIL THE REFLECTIONS AND GLARE GO AWAY!

I WOULDN'T BE WITHOUT ONE MYSELF!

NOTICE THE HOT SPOTS CAUSED BY THE SUN ON THESE TWO CARS... AND HOW IT TAKES AWAY THE DETAIL?

NOW THE POLARIZING FILTER SHOT!

NOTICE HOW THE GROUND GETS DARKER!

FILTERS

NOW COMES THAT WORD THAT SCARES ALOT OF PEOPLE WHEN THEY START USING FILTERS....THAT IS **FACTOR!**

REMEMBER....NOT ONLY DOES THE COLOR FILTER YOU USE MAKE THAT COLOR WHITE....IT DIMS THE VIEW........AND HOW MUCH IT DIMS THE VIEW IS CALLED: **FACTOR!**

IN OTHER WORDS, YOU SIMPLY MAKE THAT LITTLE HOLE BEHIND YOUR CAMERA LENS **BIGGER!**

IF YOU KEEP ON READING, I'LL EXPLAIN WHAT I MEAN AND ILLUSTRATE MY POINT SO YOU WON'T EVER FORGET HOW TO USE THOSE LITTLE ROUND PIECES OF MAGIC!

"BETTER USE A GREEN FILTER"

FILTERS

REMEMBER:

A FILTER FACTOR OF **X1** DOESN'T MEAN
ONE STOP..... IT MEANS ½ OF A STOP.....

LIKE THIS

f2.8 - f4 - f5.6 f8

A FILTER FACTOR OF **X2** DOESN'T MEAN
TWO STOPS.... IT MEANS **ONE** STOP.....

LIKE THIS

f2.8 - f4 - f5.6 - f8

A FILTER FACTOR OF **X4** DOESN'T MEAN
FOUR STOPS... IT MEANS **TWO** STOPS.....

LIKE THIS

f2.8 - f4 - f5.6 - f8

AND
A **X3** FILTER FACTOR: **f2.8 - f4 f5.6 - f8**

FILTERS

OK...SO YOU DON'T HAVE A LIGHT METER IN-SIDE YOUR VIEWFINDER AND YOU FORGOT TO ALLOW FOR THE FILTER FACTOR.....

WHAT HAPPENS?....LOOK AND SEE!

A RED CAR TAKEN WITH-OUT A FILTER LOOKS OK!

1/500 SEC. AT f16, TRI-X FILM! MIRANDA 35!

SAME CAR WITH A RED FILTER MADE THE CAR WHITE! THE FILTER FACTOR IS X4!

1/500 SEC. AT f8!

SAME SCENE WITH A RED FILTER BUT WITHOUT THE FILTER FACTOR!

1/500 SEC. AT f16!

BAD NEWS!

FILTERS

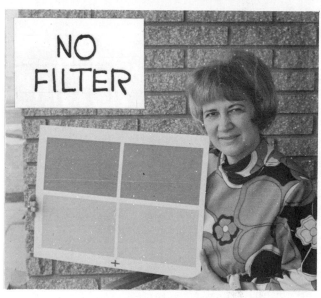
NO FILTER

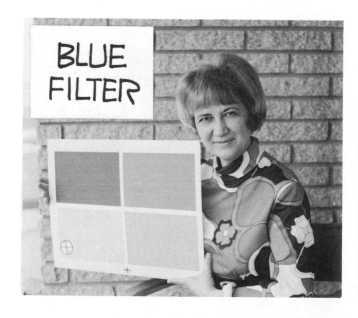
BLUE FILTER

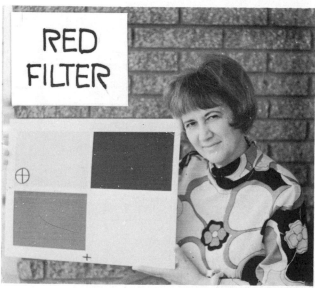
RED FILTER

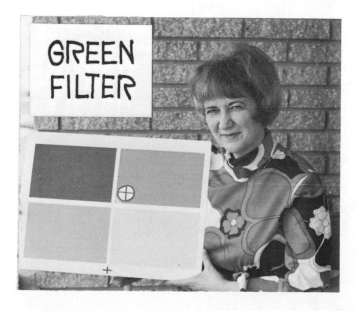
GREEN FILTER

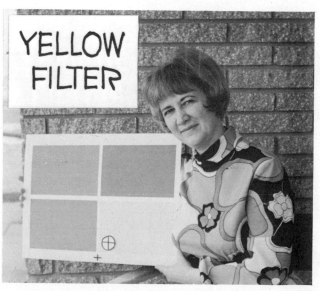
YELLOW FILTER

FILTERS

SUPPOSIN' YOU WANT A RED TULIP TO STAND OUT AGAINST THE BACKGROUND.....

f5.6 at 1/250 sec.

HERE'S THE TULIP AND IT'S VERY RED.... BUT YOU CAN'T REALLY SEE THE DIFFERENCE ENOUGH TO MAKE IT POP OUT!

THE READING FOR THIS SHOT WAS f11 AT 1/250 SEC.

THE RED FILTER MADE THE BACKGROUND DARKER AND THE RED TULIP LIGHTER!

BUT... THE RED FILTER HAS A FACTOR OF 4 AND THAT MEANS TWO STOPS BIGGER! *REMEMBER: THE FACTOR ONE MEANS HALF A STOP.... AND 2 FACTOR MEANS ONE STOP!*

REMEMBER

HERE'S TWO STOPS

f2.8 - f4 - f5.6 - f8 - f11

FILTERS

ONE VERY OUTSTANDING THING ABOUT FILTERS **IS** THEIR ABILITY TO CANCEL OUT COLORS OR STAINS YOU DON'T WANT IN THE PICTURE, THUS GIVING YOU PRETTY GOOD CONTROL OF ANY EFFECT YOU WANT! HERE IS SOME COPY MARKED WITH MAGIC MARKER BY MISTAKE... BUT WITH THE RIGHT FILTER THEY ARE JUST ABOUT ELIMINATED!

HERE'S SOME ART COPY CROSSED WITH RED!

I MARKED ON A PHOTO WITH BLUE MAGIC MARKER!

NOW A RED FILTER IS USED TO CANCEL IT OUT!

THEN I RESHOT THE PHOTO THROUGH A BLUE FILTER!

FILTERS

IF YOU HAVE A CAMERA THAT DOES NOT HAVE A METER IN THE VIEWFINDER, YOU MUST REMEMBER TO ALLOW FOR THE FILTER FACTOR... *BECAUSE* NOT ALL FILTERS HAVE THE FACTORS PRINTED ON THEM *WHICH IS REAL STUPID!* ANYWAY... TRY THESE:

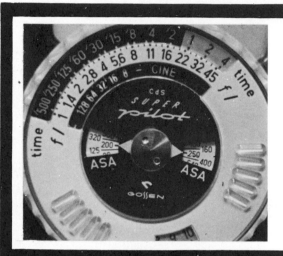

IF YOU ARE USING A YELLOW FILTER WITH A X2 FACTOR (1 STOP) YOU TURN YOUR LIGHT METER BACK TO HALF OF THE ASA *EXAMPLE:* TRI-X IS ASA 400! SET THE ASA RATING TO 200!

AND DON'T FORGET TO TURN IT BACK TO 400 AFTER THE FILTER IS OFF!

HOLD THE FILTER OVER THE FRONT OF THE LIGHT METER WHERE THE LIGHT COMES IN THE LIGHT WILL GO THROUGH THE METER AND CHANGE THE READING ... AND GIVE YOU THE FILTER FACTOR!

EVEN SUNGLASSES WORK!

OR JUST TRY AND REMEMBER!

IF YOU FORGET THE FACTOR YOUR PICTURE WILL BE *UNDER-EXPOSED!* THAT MEANS A *DARK* PRINT!

FILTERS

THERE IS NO FILTER THAT WILL PUT CLOUDS IN A GREY OVER-CAST SKY..... AND IF THERE ARE BIG BLACK THUNDER CLOUDS YOU WON'T NEED A FILTER! IF YOU CAN AFFORD ALL THE KINDS OF FILTERS, THEN GET THEMIF YOU HAVE TO CHOOSE ONLY ONE, MAKE IT A *YELLOW K-2*, BECAUSE THAT WILL GIVE YOU PLEASING BALANCE WITH A NATURAL RELATIONSHIP IN TONES!

I PERSONALLY USE ONLY TWO FILTERS, UNLESS SOMETHING SPECIAL ARISES ...THE YELLOW K-2 AND THE POLARIZING FILTER! BESIDES DARKENING THE SKY IN BLACK AND WHITE FILM, THE POLARIZING FILTER IS THE ONLY WAY TO GET A DARKENED SKY, OR A DEEP BLUE, IN COLOR SLIDE FILM!

YOU SPENT $15 FOR ONE FILTER?

THE F16 RULE

IT'S f16 NOT FIG!

THE F16 RULE

IF YOUR LIGHT METER IS BROKEN, YOU FORGOT IT... OR YOU DON'T HAVE ONE... *USE THE f16 RULE!*

OUTDOORS ONLY ON A SUNNY DAY!

HERE IT IS: USE THE ASA NUMBER OF THE FILM THAT YOU ARE USING FOR THE SHUTTER SPEED AND SET YOUR APERTURE AT f16!

EXAMPLE: TRI-X FILM • ASA **400**
CLOSEST SHUTTER SPEED IS 1/500 SEC.
SETTING: 1/500 SEC. AT f16

EXAMPLE: PLUS-X FILM • ASA **125**
CLOSEST SHUTTER SPEED IS 1/125 SEC.
SETTING: 1/125 SEC. AT f16

EXAMPLE: HIGH SPEED EKTACHROME COLOR FILM
ASA **160**
CLOSEST SHUTTER SPEED IS 1/150 SEC.
SETTING: 1/150 SEC AT f16

THIS RULE WILL NOT GIVE YOU AS GOOD RESULTS AS AN EXPOSURE METER... *BUT AT LEAST YOU'LL GET A PICTURE!*

113

COMPOSITION

I DON'T MIND COMPOSING, BUT THIS IS RIDICULOUS!

THE PROFESSIONAL WITH A SKILL CAN'T ALWAYS DESCRIBE HIS ART WITH WORDS!

I COULD EASILY FILL THIS BOOK WITH DOZENS OF LITTLE DRAWINGS SHOWING YOU THE RULES OF COMPOSITION, BUT I'M NOT WRITING THIS BOOK TO BORE YOU.... INSTEAD, I'M GOING TO *SHOW YOU* WHAT MAKES A PICTURE LOOK GOOD....AND WHAT MAKES IT LOOK TERRIBLE!

TV COMMERCIALS ARE AN EXCELLENT EXAMPLE OF THE ART OF COMPOSITION...AND THOUSANDS OF DOLLARS ARE SPENT TO ATTRACT THE EYE OF THE VIEWER!

STAY AROUND ON PURPOSE, NO MATTER HOW PAINFUL IT IS....*AND LEARN FROM THEM!*

ARE YOU READY FOR THE NITTY GRITTY?

LET'S GO!

COMPOSITION

ONE THING WE HAVE TO CLEAR UP RIGHT OFF THE BAT.....THE PICTURE AREA OF YOUR CAMERA!

ANOTHER THING IS THE SIZE OF THE ENLARGING PAPER YOU USE AND THE LAST THING IS THE KIND OF EASEL YOU USE WHEN YOU ENLARGE YOUR PICTURES !

FIRST: IF YOU'RE USING A 35mm CAMERA, YOUR PICTURE AREA WILL BE 24X36mm...OR ROUGHLY 15/16 X 17/16" AND THAT'S A **5X7 RATIO....** THE SAME RATIO USED FOR TELEVISION ART WORK !

AND SECOND:

PRINTING PAPER COMES CUT TO CERTAIN SIZES THOSE SIZES THAT ARE IN MOST DEMAND...MAINLY 4X5", 5X7", AND 8X10".... AND THAT CREATES A PROBLEM BECAUSE 4X5 AND 8X10 ARE **NOT** THE SAME **RATIO** AS 35mm

IN OTHER WORDS YOU CAN'T PRINT ALL OF YOUR PICTURE !

GOT IT? NOT ALL OF YOUR PICTURE !

THE SAME GOES FOR 11X14 TOO!

COMPOSITION

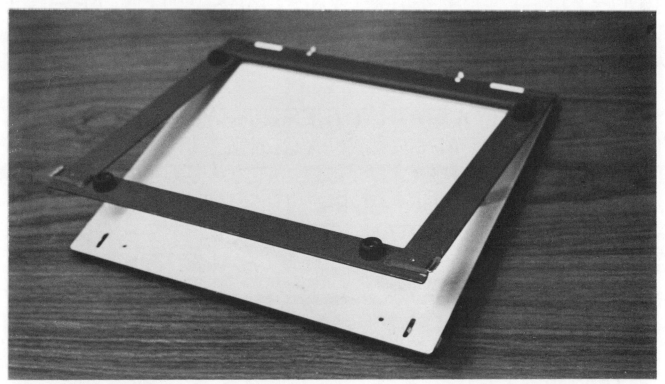

THIS IS CALLED A 4-WAY PRINTING EASEL BECAUSE ONE SIDE IS 8X10 SIZE.... AND THE BACK IS 5X7, 4X5, AND 2¼ X 3¼

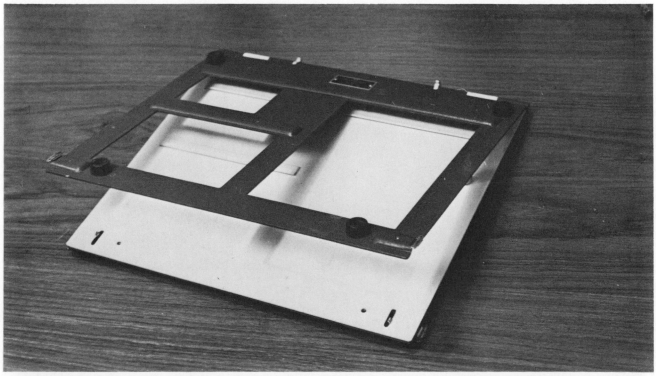

THESE EASELS HANDLE THE STANDARD PAPER SIZES AND GIVE YOU A NICE WHITE PROFESSIONAL BORDER!

COMPOSITION

YOUR FIRST SURPRISE WHEN MAKING ENLARGE-
MENTS FROM 35mm IS WHEN YOU ATTEMPT TO
MAKE 8X10 PRINTS USING THE WHOLE NEGATIVE!

YOU WILL DISCOVER THAT THERE IS MORE PICTURE
THAN THERE IS PAPER.... IN A SENSE, IT'S LIKE
TRYING TO FIT A RECTANGLE INTO A SQUARE.......
...THERE'S SOME LEFT OVER! THIS MEANS YOU MUST
NOT INCLUDE IMPORTANT THINGS ON THE EXTREME
SIDE OF YOUR NEGATIVE! *YOU HAVE TO PLAN!*

THE DARK LINE THAT'S AROUND THIS 35mm FULL-
FRAME PRINT IS THE 8X10 RATIO OF STANDARD
ENLARGING PAPER!
THIS IS ALSO TRUE FOR 4X5 AND 11X14 PAPER!

COMPOSITION

THINGS GO A LITTLE BETTER FOR THE 5X7 PRINT, ALTHOUGH THERE IS STILL A SMALL AMOUNT OF CUT-OFF AT THE EDGES!

THERE IS ONLY ONE WAY TO GET A FULL NEGATIVE PRINT.... AND THAT IS WITH A CAMERA WITH A 2¼ X 2¾ NEGATIVE! THIS IS REALLY NOT A SERIOUS PROBLEM, UNLESS YOU DON'T *THINK* A LITTLE WHEN YOU TAKE YOUR PICTURE!

THE DARK LINE HERE IS A 5X7 FRAME, WHICH IS ALSO A STANDARD PAPER SIZE! IF LINDA'S HEAD HAD BEEN TOO NEAR THE EDGE OF THE 35mm FULL FRAME, I WOULD HAVE BEEN IN BIG TROUBLE!

COMPOSITION

MORE CAN BE DONE WITH THE 2¼ X 2¼, OR SQUARE NEGATIVE WHEN IT COMES TO "PULLING-OUT" A PICTURE! THIS IS CALLED *CROPPING!* JUST PUT YOUR MAIN SUBJECT NEAR THE CENTER WHEN TAKING THE SHOT AND YOU CAN CROP OUT ALL KINDS OF COMPOSITIONS!

LINDA AGAIN! NOTICE HOW THE 8X10 RATIO INSIDE OF THIS SQUARE NEGATIVE WORKS LIKE A CHARM!

HEAD TOO LOW AND NEGATIVE AREA AT TOP OF HEAD BAD!

TIP IS TOO GREAT, AS IT WILL MAKE PEOPLE TURN THE PICTURE

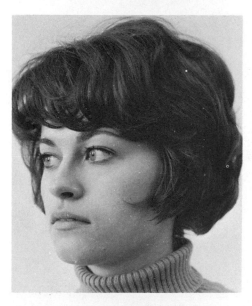

FACE TOO FAR TOWARD LEFT SIDE OF FRAME

HEAD TOO LOW AND CHIN IS TOO CLOSE TO BOTTOM

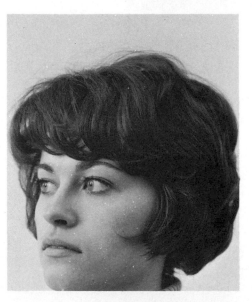

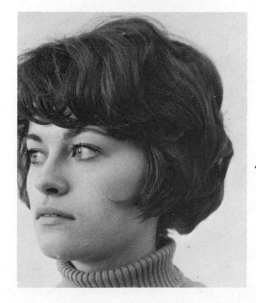

WORST ONE OF ALL... NOTICE HOW IT TENDS TO BOTHER THE EYE?

WOMEN DON'T LIKE THESE CLOSE-UPS!

COMPOSITION CROP THIS WAY!

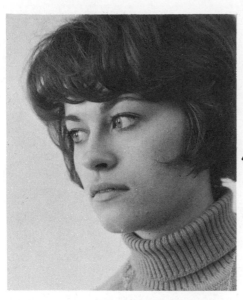

SLANTING IS ALWAYS A GOOD WAY TO ADD GLAMOUR! THIS ONE IS BEST!

THIS CROPPING DOES ALOT TO ATTRACT YOUR ATTENTION →

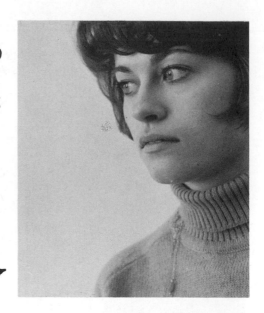

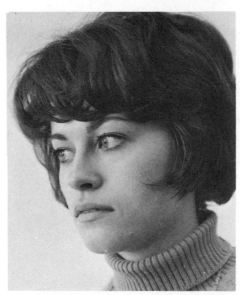

MORE HAIR IS SHOWING.. AND THIS IS A SAFE COMPOSITION FOR PORTRAITS

TIP THE OTHER WAY AND CUT-OFF HEAD IS INTERESTING →

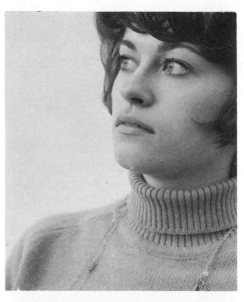

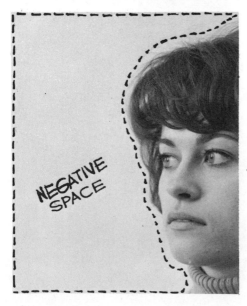

NEGATIVE SPACE

THIS IS THE MOST DRAMATIC SHOT BECAUSE OF ALL THE NEGATIVE SPACE

GOOD SHOT FOR A YOUNG GIRL LIKE PAM →

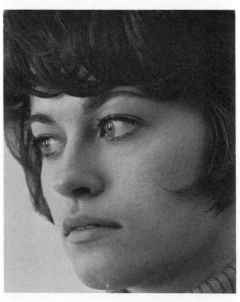

COMPOSITION *AVOID THESE!*

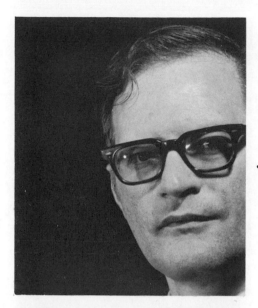

BEST ONE OF THE BAD ONES BUT A LITTLE BIT TOO MUCH CUT OFF HERE!

SHOULD BE ABLE TO SEE HAIR LINE →

FACE TOO NEAR WRONG SIDE OF FRAME!

TIPPED IN THE WRONG WAY AND CUT OFF TOO MUCH

BILL LOOKS LIKE HE IS PEEKING THROUGH A WINDOW!

DOESN'T MEAN ANYTHING.... TOO CLOSE!

COMPOSITION CROP THIS WAY!

FACE CUT OFF JUST ABOUT RIGHT... GOOD COMPOSITION FOR MAN'S FACE!

MEN LOOK GOOD CROPPED THIS WAY →

NOT TOO BAD AND THE SLANT TO LEFT ADDS GLAMOUR

STRAIGHT SHOT LOOKS FAIR! BUT TRY FOR SOMETHING DIFFERENT →

DIFFERENT PLACEMENTS DRAW ATTENTION

ALWAYS SHOW THE HAIR LINE! THIS MAKES BILL LOOK TALLER →

COMPOSITION
2¼×2¼ VERTICAL

THE SQUARE NEGATIVE IS MORE VERSATILE WHEN IT COMES TO "PULLING-OUT" A PICTURE! IF YOU'RE NOT SURE WHAT KIND OF A COMPOSITION YOU WANT, YOU CAN PUT THE SUBJECT IN THE MIDDLE, LIKE I DID WITH LINDA, AND THEN CROP-OUT ANY SIZE YOU WANT FOR A PLEASING PICTURE...*ONE THAT LOOKS PRO!*

ACTUAL SIZE!

NEGATIVE SPACE

PICTURE CROPPED IN TOO TIGHT! IT'S GOOD, BUT WHY CUT A BEAUTIFUL GIRL IN HALF?....YOU MUST NOT BE AFRAID TO USE NEGATIVE SPACE!

NOTICE THAT LINDA IS NOT CENTER, BUT OVER TO THE LEFT SIDE LOOKING RIGHT! THE OPEN SPACE IN FRONT OF HER IS CALLED NEGATIVE SPACE...*VERY EFFECTIVE!*

COMPOSITION
HERE'S THE FINISHED PRINT!

COMPOSITION

SOMETIMES PRINTING THE ENTIRE NEGATIVE DOES NOT GIVE THE BEST COMPOSITION! THERE ARE TIMES WHEN YOU WANT TO *"PICK-OUT"* SOMETHING IN THE PICTURE, OR GET RID OF SOME OF THE BACKGROUND.... AND BELIEVE IT OR NOT....THERE ARE TIMES WHEN THE MORE YOU TRY TO *"PICK-OUT"*, THE BETTER THE COMPOSITION BECOMES...LIKE THIS:

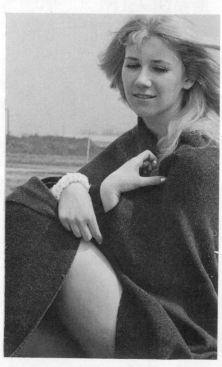

THIS SPEED EASEL MAKES ONLY ONE SIZE PRINT...THIS ONE IS FOR 8X10 ! *PAPER SLIDES IN EITHER SIDE !*

COMPOSITION
THE ADJUSTABLE EASEL

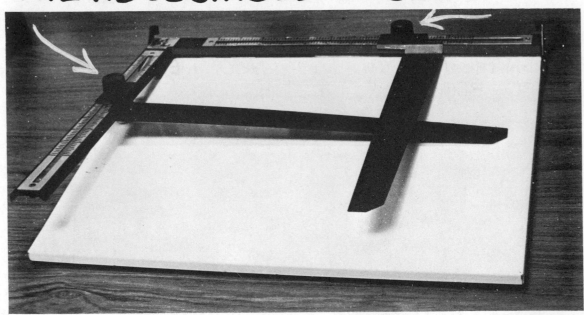

THE ADJUSTABLE EASEL CAN NOT ONLY MAKE ALL THE STANDARD SIZE PRINTS BUT ANY OTHER UNUSUAL SIZE THAT WILL MAKE IT LOOK MORE PLEASING!
THE LITTLE ROUND KNOBS, WHERE THE ARROWS ARE POINTING ARE LOOSENED, AND THE LONG METAL STRIPS ARE MOVED TO FORM THE PICTURE AREA!

COMPOSITION
2¼ × 2¼ HORIZONTAL

THIS LENDS ITSELF TO A NATURAL HORIZONTAL BECAUSE OF THE BIG SKY AREA!

BUT THERE ARE TOO MANY DISTRACTING THINGS ABOUT!

ACTUAL SIZE

STILL TOO MANY OBJECTS SITTING AROUND STEALING FROM PICTURE!

MODEL IS IN THE CENTER AND THE WHOLE THING IS TOO HEAVY ON RIGHT!

MUCH BETTER, BUT THE MODEL IS STILL CENTERED, AND PICTURE IS STILL OVER-WEIGHT ON RIGHT SIDE! SOLUTION IS TO MOVE MODEL TO THE LEFT SIDE!

COMPOSITION

HERE IS ONE SOLUTION: GET THE IMPORTANT SUBJECT OVER TO THE LEFT OF THE PICTURE AREA BECAUSE THE NATURAL MOVEMENT OF THE EYE IN A COMPOSITION IS LEFT TO RIGHT..... AND DOWN!
ACTUALLY, THIS SHOT SHOULD HAVE BEEN TAKEN A COUPLE OF FEET CLOSER, WHICH WOULDN'T HAVE MADE A BIG BLOW-UP NECESSARY! BETTER TO SHOOT AT DIFFERENT DISTANCES AND PICK THE BEST!

MODEL SHOULD REALLY BE MOVED FARTHER TO LEFT OF PICTURE AREA, BUT THERE WAS NO MORE NEGATIVE! JUST BECAUSE THERE ARE MORE POSSIBILITIES IN A SQUARE NEGATIVE DOESN'T MEAN TO GET SLOPPY!

COMPOSITION
2¼ × 2¼ VERTICAL

THIS IS NOTHING BUT A *SNAPSHOT,* AND THAT'S ALL IT WILL EVER BE! THE SQUARE NEGATIVE IS WASTED AND THE BACKGROUND IS CLUTTERED AND SHARP, CAUSED BY A SMALL LENS OPENING! TO ADD TO THE CONFUSION, JOHN HUTTON IS WEARING GLASSES, WHICH REFLECTED THE FLASH BULB GOING OFF!

ACTUAL SIZE

NOW...NOTICE THE BOLT COMING OUT OF JOHN'S NECK? THAT'S PART OF A FLOURENCENT LIGHT IN THE BACKGROUND........ TYPICAL SNAPSHOT!

HAVE TO BLOW IT UP AND CROP-IN REAL TIGHT TO GET THE BOLT OUT! REFLECTION IN GLASSES ARE TOO APPARENT! *TAKE GLASSES OFF!*

COMPOSITION
2¼ × 2¼ HORIZONTAL

HERE'S DAVID DOING HIS HOMEWORK!
ANOTHER SNAPSHOT.......BUT A
LOT EASIER TO SAVE!

GOOD HORIZONTAL FORMAT!

ACTUAL SIZE

WHOLE BODY IS
TOO CENTERED,
WITH TOO MUCH
SOFA AND WALL
SHOWING!
ORIGINAL SHOT
SHOULD HAVE
BEEN CLOSER!

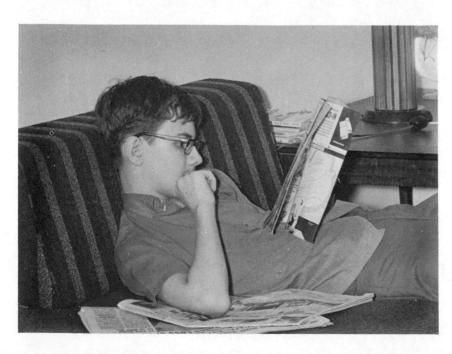

MUCH BETTER....
BUT COMPLETE
BODY ADDS MORE
TO A HORIZONTAL
FEELING!
USE A LONGER
FORMAT WITH AN
ADJUSTABLE
EASEL!

COMPOSITION

ANOTHER INSTANCE WHERE THE NEGATIVE WAS BLOWN-UP TOO BIG! YOU SHOULD SHOOT SO YOU CAN USE AS MUCH OF THE NEGATIVE AREA AS POSSIBLE! THE REASON BEING THAT REAL BIG BLOW-UPS LOSE SHARPNESS AND ARE GRAINY!
IT'S TRUE THAT IN SOME CASES THEY MAY NOT LOOK GRAINY BECAUSE OF FINE GRAIN FILM, BUT THEY WILL CERTAINLY BE LESS SHARP!
IT'S A GOOD IDEA TO MOVE YOUR SUBJECT AWAY FROM A BUSY BACKGROUND..... *IF YOU CAN!*

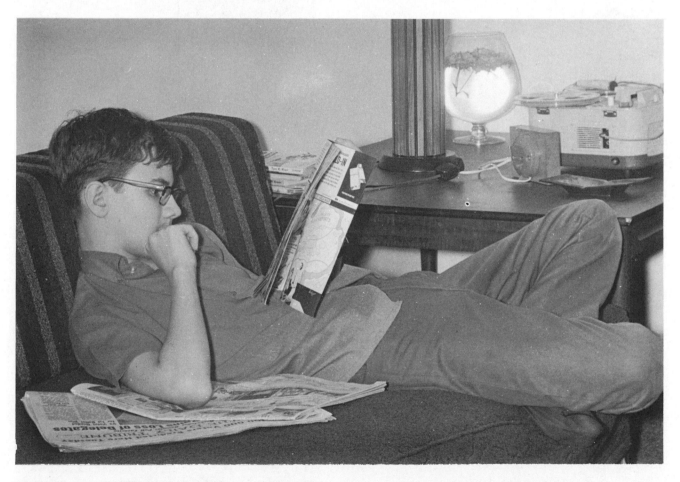

THIS IS ABOUT THE BEST YOU CAN DO FROM A SNAPSHOT! NOTICE HOW THE COMPOSITION IS HELPED BY PLACING THE SUBJECT TOWARD THE LEFT SIDE OF THE FRAME! *DID I SAY HOMEWORK?*

COMPOSITION 2¼×2¼ VERTICAL

THIS SHOT COULD EASILY BE TURNED INTO A HORIZONTAL... BUT LET'S MAKE IT A VERTICAL!

THE SKY AREA IS VERY IMPORTANT, IN THAT IT ADDS IMPACT TO THE PICTURE! SO... YOU MUST USE THE SKY AS THE IMPORTANT ELEMENT.... AND THAT WILL DRAW ATTENTION TO THE PEOPLE!

ACTUAL SIZE

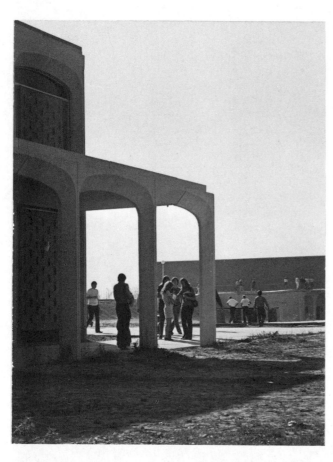

SKY AREA AND BUILDING ARE EQUAL WHICH CREATES A STATIC FEELING! SOME PEOPLE WOULD LIKE THIS ONE! IT LACKS ORIGINALITY AND BECOMES JUST ANOTHER ONE OF THOSE PRINTS!

AT LEAST THE BUILDING AREA IS LARGER THAN THE SKY AREA! THAT'S A STEP IN THE RIGHT DIRECTION! OF COURSE THE PRINT IS TOO LIGHT, AND TOO MUCH OF THE GROUND IS SHOWING!

134

COMPOSITION
HERE'S THE FINISHED PRINT!

NOTICE THE GREAT EXPANSE OF SKY AREA!

AND ALSO HOW THE WEIGHT OF THE PICTURE COMPOSITION IS TO THE LEFT!

ANOTHER IMPACT TO THIS PRINT IS THE DARK BUILDINGS AND THE BRIGHT SKY! THIS WAS FUN TO DO!

COMPOSITION
2¼ × 2¼ HORIZONTAL

THERE ARE SEVERAL WAYS TO GO WITH THIS ONEAS A MATTER OF FACT, THE SQUARE IN THIS CASE IS A GOOD COMPOSITION.. BUT LET'S TRY TO IMPROVE ON IT!

ACTUAL SIZE

THE BARN IS JUST A LITTLE TOO LOW ON THIS ONE! CUTTING OFF THE REFLECTION IN THE WATER DESTROYS THE WHOLE MOOD OF THE PICTURE!

PICTURE TOO BIG FOR FRAME AND CAN'T SEE TRUNKS OF TREES.....AND REFLECTIONS ARE STILL NOT THERE!

WHOLE SCENE IS INCOMPLETE!

136

COMPOSITION

BY INCLUDING THE TREE TRUNKS, WE INTRODUCE STABILITY INTO THE PICTURE! NOTICE THIS TIME THE BARN IS ON THE RIGHT SIDE... THAT'S BECAUSE THE BARN IS *REALLY NOT* THE SUBJECT! THE SUBJECT IS THE ENTIRE SCENE AS A WHOLE... BUT NOTICE THAT THE BALANCE OF THE SCENE IS FROM THE TREES ON THE LEFT, WHICH LEAD THE EYE FROM LEFT TO RIGHT.... *STRAIGHT FOR THE BARN!* THE REFLECTION DRAWS MORE ATTENTION TO THE BARN, AND THIS BALANCES THE ENTIRE SCENE!

MOST OF THE BOTTOM OF THE ACTUAL SIZE PICTURE WAS CROPPED-OUT! THAT'S BECAUSE, AS YOU'LL NOTICE, THE PICTURE IS ALMOST THE SAME UP-SIDE DOWN AS IT IS RIGHT-SIDE UP! *TAKEN WITH BRONICA...NORMAL LENS*

COMPOSITION
35mm VERTICAL

A PRETTY GIRL LIKE MARTI LOOKS EVEN PRETTIER DOING SOMETHING! GIRLS FEEL MORE NATURAL ON A TELEPHONE, MAKING FOR A BETTER PICTURE!
HERE WE GO AGAIN WITH WASTED NEGATIVE ABOVE HER HEAD!
IF YOU DON'T INTEND TO USE THE FULL NEGATIVE OF YOUR 35mm CAMERA, GET A 2¼ X 2¼ AND YOU WON'T BLOW IT UP SO BIG!

FULL FRAME

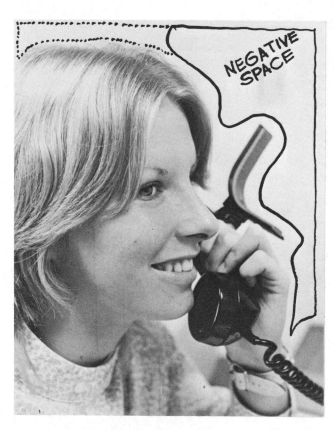

NEGATIVE SPACE

GOOD NEGATIVE SPACE ON RIGHT... BUT AREA ON TOP OF HEAD HITS YOU IN THE EYE! PICTURE PRINTED ON LIGHT-SIDE WHICH GIVES GIRLS BETTER LOOKING COMPLEXIONS!

PRINT TOO DARK! SEEING TOP OF HEAD BOTHERS ME AGAIN! A LITTLE TOO MUCH NEGATIVE SPACE IS BETTER THAN NOT ENOUGH! HAND TOO NEAR END OF THE PICTURE! EYES CENTERED!

COMPOSITION

BY MOVING MARTI MORE TO THE LEFT AND CUTTING-OFF SOME OF THE HEAD, WE CREATE A DRAMATIC SHOT WITH A LOT OF NEGATIVE SPACE ON THE RIGHT AND PRINTED THE PICTURE ON THE LIGHT-SIDE!

WE ALSO TOOK HER EYES OFF-CENTER!

COMPOSITION
35mm VERTICAL

THERE'S ALOT OF SKY AREA IN THIS PICTURE, AND AS A RESULT, IT HAS TO BE CROPPED OUT!

THAT'S A WASTE OF NEGATIVE!

A BETTER IDEA WOULD HAVE BEEN TO COME CLOSER ...OR GETTING MORE OF HER BODY!

AS A RESULT....
....WE HAVE A SQUARE!

FULL FRAME

IT'S NOT NECESSARY TO PUT HER RIGHT IN THE MIDDLE OF THE FRAME TO DRAW ATTENTION! NOT ENOUGH NEGATIVE SPACE! *PRINT IS TOO DARK!*

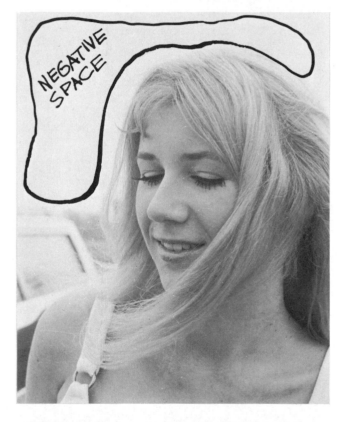

NEGATIVE SPACE

THIS IS A LITTLE BETTER, BUT THE NEGATIVE SPACE IS EQUAL TO THE SUBJECT AREA! IT WAS PRINTED ON THE LIGHT-SIDE...WOMEN LOOK BETTER THAT WAY!

COMPOSITION PRINTED ON LIGHT-SIDE!

SOLUTION IS TO MAKE NEGATIVE SPACE THE PART THAT DRAWS ATTENTION FIRST, DRAWING THE EYE TO THE BEAUTIFUL GIRL..... LEFT TO RIGHT AGAIN!

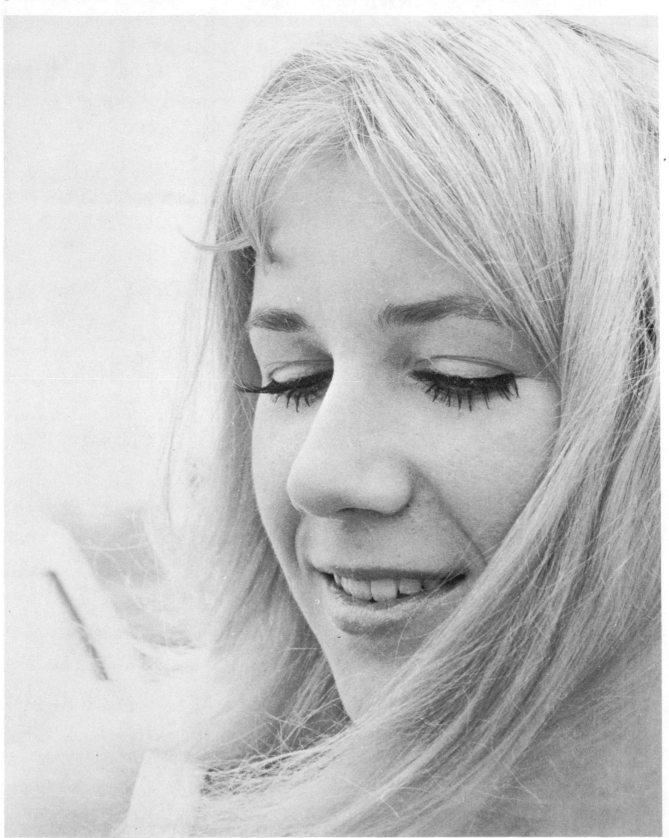

COMPOSITION
35 mm VERTICAL

THIS IS A NATURAL FORMAT FOR A 35mm NEGATIVE.. *A VERTICAL*..FOR A PICTURE LIKE THIS!

THIS FULL FRAME SHOT IS GOOD JUST LIKE IT IS.. BUT WE CAN STILL IMPROVE ON IT!

IT'S JUST A MATTER OF WHERE YOU WANT THE EYE TO GO!

IN THIS FULL FRAME, BOTH BILL AND THE CAMERA ARE FIGHTING FOR THE VIEWER'S ATTENTION!

FULL FRAME

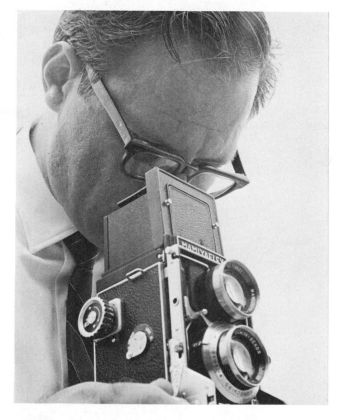

THIS BLOW-UP IS TOO BIG, AND AS A RESULT....THE BOTTOM CAMERA LENS IS CUT OFF! IF THAT DOESN'T BOTHER YOU, IT SHOULD!

BOTH HEAD AND CAMERA TAKING UP ONE HALF OF PICTURE AREA, CAUSING A STATIC SITUATION! HAND IS CUT-OFF AT BAD PLACE!

142

COMPOSITION

CAMERA IS MOVED UP IN FINAL PRINT TO SHOW MORE OF HAND... AND MORE NEGATIVE SPACE ON RIGHT SIDE, CAUSING EYE TO FOLLOW FROM LEFT TO RIGHT...AND UP!

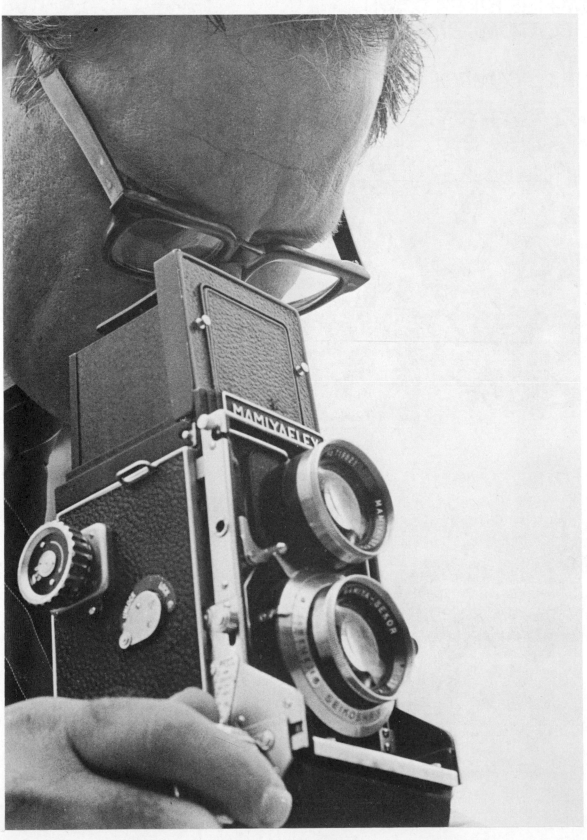

COMPOSITION
35 mm HORIZONTAL

NOTICE HOW THE EYE FOLLOWS THE BIKES DOWN TO THE BOTTOM *RIGHT!*

A NATURAL COMPOSITION!

FULL FRAME

JUST BLOWING UP PICTURES REAL BIG IS A WASTE OF TIME AND PAPER! IT MEANS NOTHINGAND LACKS IMAGINATION!

A GOOD TRY, BUT TOO MUCH OF THE BUILDING ON THE RIGHT IS CUTTING INTO THE PICTURE!

PICTURE NEEDS TO BE MORE HORIZONTAL!

COMPOSITION

HERE'S THE FINAL PRINT MADE MORE HORIZONTAL WITH NOT SO MUCH BUILDING AT RIGHT SHOWING! MORE SIDEWALK ADDED TO GIVE OPEN SPACE TO DRAW THE EYE TO RIGHT AND DOWN TO RIGHT!

GOOD COMPOSITION IS A LOT OF COMMON SENSE! IF A PICTURE LOOKS BAD, AND I MEAN IF IT JUST BOTHERS YOU, AND MAKES YOU ANNOYED....THEN CHANGE IT!
BE SURE AND AVOID "CENTERING" YOUR SUBJECT!

PRINTED ON A NO. 4 CONTRAST ENLARGING PAPER TO MAKE THE BIKES POP-OUT AGAINST THE SIDE-WALK! CONTRAST MAKES THIS PHOTO OUTSTANDING!

COMPOSITION
35mm HORIZONTAL

A SNAPSHOT TAKEN FROM
A HIGH POSITION...TO LOOK
MORE INTERESTING!

BUT STILL A SNAPSHOT!

FULL FRAME

BLOWING UP THIS
ONE DID NOTHING
..........*EXCEPT*
MAKING IT LESS
INTERESTING....
PRODUCING MORE
GRAIN AND CUTTING
DOWN ON THE
SHARPNESS!

A LITTLE BETTER
BUT TOO SQUARE!

DO I HAVE TO SAVE IT?

WELL, OK!

146

COMPOSITION

USING AN ADJUSTABLE EASEL TO STRETCH IT OUT MORE HORIZONTALLY, AND PRINTING AGAIN ON A NO.4 CONTRAST PAPER, IT BECOMES MORE INTERESTING.....

...BUT NOT MUCH!

THERE ARE JUST TOO MANY CARS POINTING IN ALL DIRECTIONS....NOTHING HOLDS THE INTEREST.....THE EYE WANDERS ALL OVER THE PLACE!

I LIKE THE SKY... IT'S RESTFUL!

I SUPPOSE IF YOUR CAR OR CAMPER WERE IN THIS PICTURE, YOU MIGHT FEEL DIFFERENTLY! BUT EVEN IF IT WERE, THAT WOULDN'T MAKE IT A GREAT PICTURE! *TELEPHONE POLES IN THIS PICTURE ARE BAD!*

COMPOSITION
35mm HORIZONTAL

ANOTHER NATURAL FOR
A 35mm NEGATIVE!
THEY ALL SEEM TO LOOK
GOOD...BUT IT'S A
LITTLE BUSY IN THIS ONE!

FULL FRAME

THE 8X10 RATIO
OF THIS PRINT IS
TOO SQUARE FOR
IMPACT.......THE
BOOKS LOOK TOO
SQUASHED TO-
GETHER!
NEEDS A LONGER
LOOK FOR IMPACT!

THIS BIG BLOW-UP
DIDN'T HELP!
PILE OF BOOKS AT
SIDE ADDS SOME
INTEREST!

THIS ONE LOOKS
MORE SQUARE
THAN THE FIRST
ONE..*MAKE LONGER!*

COMPOSITION

I USED AN ADJUSTABLE EASEL AND STRETCHED IT OUT A LITTLE LONGER, MAKING IT MORE HORIZONTAL! TO MAKE THE BLACKS BLACKER, AND THE WHITES WHITER, I PRINTED ON A NO.4 ENLARGING PAPER, WHICH ADDED MORE CONTRAST!

IT'S REALLY NOT A VERY GOOD PICTURE BY ITSELF! JUST A SNAPSHOT! IT MIGHT BE GOOD FOR AN ADVERTISEMENT OF SOME SORT!
YOU COULD USE IT TO CHECK THE SHARPNESS OF YOUR CAMERA LENS!

DON'T BE AFRAID TO PRINT ON A CONTRASTY PAPER FOR SPECIAL EFFECTS! ESPECIALLY IN A CASE LIKE THIS, WHERE IT MADE ALL THE BOOKS POP-OUT!

COMPOSITION

DON'T TAKE PICTURES OF PEOPLE THIS WAY

THE REASON IS OBVIOUS...
LOOK AT THE WASTE OF
NEGATIVE AREA ON EACH SIDE
OF JOHN HUTTON!
WHEN YOU SHOOT PEOPLE
THIS WAY, YOU HAVE A
SMALLER HEAD ON THE
NEGATIVE.... AND YOU HAVE
TO BLOW THEM UP BIGGER!

TAKE THEM THIS WAY

A BIGGER HEAD, LESS WASTED
NEGATIVE, NOT SUCH A BUSY
BACKGROUND, AND SHARPER
PICTURES BECAUSE YOU WON'T
HAVE TO BLOW THEM UP AS BIG!

GET OUT OF THE HABIT OF
SHOOTING EVERYTHING IN THE
HORIZONTAL FORMAT WITH YOUR
35mm CAMERAUNLESS
IT LENDS ITSELF TO THE SUBJECT!

AND BESURE TO FOCUS ON THE EYES!

LIGHTING

THERE IS NO SINGLE FORMULA FOR THE BEST LIGHTING ... THERE ARE TOO MANY VARIATIONS AND DIFFERENCES IN PEOPLE'S TASTES ... AND EXPERIENCE IS STILL THE BEST TEACHER!

LET US EXPLORE THE POSSIBILITIES!

LIGHTING

I'M NOT GOING TO GIVE YOU A SECRET FORMULA ON LIGHTING THAT WILL ALL OF A SUDDEN TURN YOU INTO A PROFESSIONAL PHOTOGRAPHER FORGET IT..... THERE JUST AREN'T ANY..... BUT THERE *ARE* LOTS OF BOOKS ON THE SUBJECT THAT TRY TO DO JUST THAT!

THERE IS A SIMPLE ANSWER:

FORGET ALL ABOUT LIGHTING AND ARRANGE YOUR SUBJECT THE WAY YOU WANT IT TO LOOK IN YOUR PICTURE IF IT LOOKS RIGHT........ THE LIGHTING WILL BE CORRECT!

BUT IF YOU GET HUNG-UP ON ALL THE RULES OF LIGHTING, IT'S GOING TO COME OUT DIFFERENT THAN WHAT YOU STARTED OUT TO PHOTOGRAPH!

DON'T FORGET: LIGHTING MUST NOT DISTRACT FROM YOUR PORTRAIT OR SUBJECT!

LIGHTING

TO AVOID TERRIBLE MISTAKES IN LIGHTING.... YOU MUST REMEMBER THIS: **"YOU GET WHAT YOU SEE."** EVERY SUBJECT IS DIFFERENT UNDER LIGHTS......AND WHAT IS GOOD LIGHTING FOR ONE PERSON, ISN'T GOOD FOR ANOTHER! STUDYING DIAGRAMS IS THE WRONG WAY TO STUDY LIGHTING! BELOW ARE TWO GIRLS SHOT UNDER SIMILAR LIGHTING..... BUT LOOK DIFFERENT!

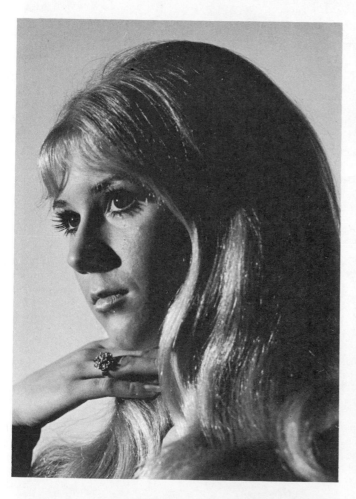 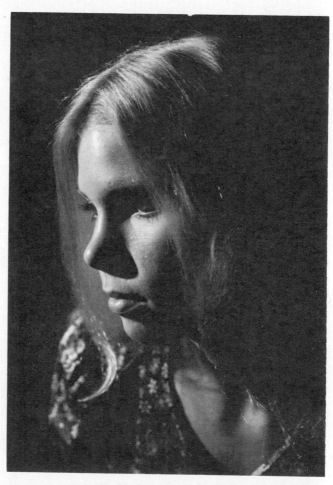

THE PICTURES OF THE GIRLS AREN'T EXACTLY THE SAME, *BUT THEY ARE CLOSE ENOUGH* TO SHOW THE EFFECTS OF THE SAME LIGHTING ON TWO FACES!

YVONNE, OF COURSE, HAS A DIFFERENT FACE, WHICH IS WHY THE SHADOW CAST BY HER NOSE AND BROW, ARE SO DIFFERENT...SHE MIGHT LOOK BETTER BY WINDOW!

LIGHTING
BASIC LIGHTING

JOE, IS AN EXAMPLE OF BASIC LIGHTING.....OR SOMETIMES CALLED : 45 DEGREE LIGHTING! IN THIS TECHNIQUE, THE BRIGHT KEY-LIGHT IS UP HIGH AND AT A 45 DEGREE ANGLE!

WHEN IT POINTS DOWN, IT CASTS A TRIANGULAR PATCH OF LIGHT UNDER ONE EYE!

A SOFT FILL-IN LIGHT IS USED ON JOE'S RIGHT TO LIGHTEN-UP THE DARK SHADOWS!

IN THE CASE OF ROY...ON THE BOTTOM...NO FILL-LIGHT WAS USED, AND THE SHADOWS BLOCKED-UP...THE LEFT SIDE OF ROY'S FACE IS OVER-EXPOSED AS A RESULT!

TRY TO SHOW BOTH EYES IN THE BASIC LIGHTING SET-UP... OR IT'S NOT BASIC!

LIGHTING
HIGH-KEY
LIGHTING

MARIA IS A GOOD SUB-JECT FOR HIGH-KEY LIGHTING! NOTICE THAT UNLIKE A NORMAL PRINT, THERE ARE NO BLACKS... ONLY WHITES AND GRAYS! MARIA'S HAIR IS VERY DARK!
NOTICE ALSO HOW THE SKIN IS WASHED-OUT!

THERE IS AN OVERALL GRAY... EVEN THE EYES, AND THE REST OF HER FEATURES ARE ON THE GRAY SIDE! ANOTHER OUTSTANDING THING THAT HIGH-KEY LIGHTING DOES IS REMOVE ALL FACIAL BLEMISHES AND SKIN PORES! THE WOMEN LOVE IT BECAUSE IT MAKES THEM LOOK YOUNGER! INCLUDE A HIGH-KEY PICTURE OF YOUR SUBJECT ALONG WITH NORMAL PRINTS... AND THEY'LL WANT MORE!

THE LIGHTING IS VERY SIMPLE... JUST TWO KEY LIGHTS... ONE ON EACH SIDE OF THE SUBJECT AT 45 DEGREES, AND AT EYE LEVEL! I ALWAYS OVER-EXPOSE BY ONE STOP AND GIVE NORMAL DEVELOPING!

TRI-X, EXPOSURE INDEX: 200

LIGHTING
WINDOW
LIGHTING

PAM IS A NATURAL FOR WINDOW LIGHT...THIS IS THE MOST FLATTERING LIGHT YOU CAN FIND......PROVIDED YOU DON'T GET TOO CLOSE TO THE WINDOW! A WHITE CARD WAS ON HER LEFT TO SOFTEN THE SHADOWS!

NOTICE THE DIFFERENCE WHEN THE FACE IS TOO CLOSE TO THE WINDOW, AND LIGHTS AREN'T USED TO SOFTEN-UP THOSE SHADOWS! THERE'S TOO MUCH BLACK IN LINDA'S FACE...AND AS A RESULT, SOME OF THE WHITES ARE OVER-EXPOSED!

THE BRIGHT SIDE OF HER FACE WAS f5.6 AT 1/60, AND THE DARK SIDE WAS f2.8...SO I SHOT AN AVERAGE: f4 AT 1/60

WINDOW LIGHT IS GOOD FOR MEN TOO !

LIGHTING
EVEN
LIGHTING

CINDY IS A GOOD MODEL
FOR EVEN-LIGHTING!
ALTHOUGH IT WOULDN'T
TAKE MUCH TO TURN
THIS INTO A HIGH-KEY
PRINT, MUCH DETAIL
WOULD BE LOST IN THE
FEATURES IN DOING SO!

THERE IS JUST A HINT OF BLACK AND WHITE, AND THE
GRAYS ARE BEAUTIFUL! EVEN-LIGHTING GIVES A
NATURAL APPEARANCE, AND STILL REMOVES BLEMISHES
AND SKIN PORES! NOTICE THAT THE SHADOW BEING
CAST ON THE FOREHEAD IS NOT OBJECTIONABLE...AND
ALL FEATURES ARE WELL-FORMED...VERY PRETTY GIRL!

KEY-LIGHT AT RIGHT OF CINDY, 45° AND JUST ABOVE
EYE LEVEL! FILL-LIGHT ON HER LEFT WITH DIFFUSION
SCREEN, CLOSE ENOUGH TO KILL DARK SHADOWS!

LIGHTING

GLAMOUR LIGHTING

THIS GLAMOUR SHOT OF LINDA IS FROM ONE STRONG KEY-LIGHT, ABOVE EYE-LEVEL, AND FURTHER RIGHT OF THE MODEL... ALMOST TO THE SIDE, SO THAT THE NOSE CASTS A VERY DARK SHADOW... DOWN AND TO ONE SIDE... *LIKE THIS!*

DOROTHY IS SHOT WITH A STRONG KEY-LIGHT ALMOST DIRECTLY OVERHEAD, AND COMING FROM HER RIGHT! NOTICE THE TRIANGULAR PATCH OF LIGHT UNDER HER LEFT EYE THAT IS SOME-WHAT LIKE BASIC 45° LIGHTING, BUT MORE PRO-NOUNCED, WITH DARKER SHADOWS!
A DIFFUSED FILL-LIGHT ON HER LEFT PREVENTED THE SHADOWS FROM BLOCKING-UP!

REMEMBER: YOU MUST BE ABLE TO SEE BOTH EYES CLEARLY!

LIGHTING ELECTRONIC FLASH

SCIENTIFICALLY SPEAKING.....
ELECTRONIC FLASH IS CAUSED
BY INSTANTANEOUS ELECTRIC
DISCHARGE BETWEEN THE TWO
ELECTRODES IN A GLASS TUBE
FULL OF GAS!
THE ADVANTAGE IS A VERY SHORT
DURATION FLASH OF LIGHT THAT
FLOODS THE PICTURE AND
FREEZES THE ACTION!

ELECTRONIC FLASH HELD UNDER RAY'S CHIN

ELECTRONIC FLASH PICTURES ARE REALLY SHARP! THE
REASON FOR THIS IS THE SHORT DURATION OF THE FLASH OF
LIGHT THAT COMES FROM THE UNIT! ACTUALLY, THE DURATION
OF THE FLASH IS ANYWHERE FROM 1/300th OF A SECOND,
FROM A LOW VOLTAGE UNIT, TO 1/1000000th OF A SECOND,
PRODUCED BY A MICROFLASH UNIT! MOST OF THE FLASH
UNITS PEOPLE USE, ARE 1/1000th OF A SECOND!

IMPORTANT: YOU MUST
SET YOUR SHUTTER SPEED TO
THE **X** MARK ON YOUR DIAL
FOR ELECTRONIC FLASH PICS,
OR YOU WILL GET ONLY A
PART OF A PICTURE! SOME
DIALS HAVE A COLORED
NUMBER OR A LITTLE FLASH
MARK!
BE SURE TO READ YOUR
CAMERA INSTRUCTION BOOK
FOR THE CORRECT SETTING!

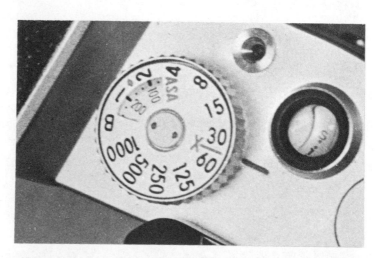

HERE IS THE SHUTTER SPEED DIAL ON A 35m
MIRANDA! THE X MARK IS WHERE YOU SET IT
FOR ELECTRONIC FLASH *OR ELSE!*

LIGHTING

SUNLIGHT

THERE IS AN OLD RULE OF EXPOSURE THAT I STILL GO BY BECAUSE IT STILL WORKS FOR BLACK AND WHITE FILM: *"EXPOSE FOR THE SHADOWS AND LET THE HIGHLIGHTS TAKE CARE OF THEMSELVES"* THE PICTURE OF MR. ROPES AT RIGHT SHOWS WHAT CAN HAPPEN IF YOU DON'T!

THE RESULT OF NOT THINKING!

NOW, CHECK THIS ONE OF LINDA, TAKEN IN THE BRIGHT SUN ON A BEACH! NOTICE THERE ARE NO BLACK SHADOWS AND NO BURNED-OUT HIGHLIGHTS! ALL I DID WAS TAKE A METER READING FROM THE SHADOW AREA! THE FILM WAS PLUS-X, AND THE SHADOWS GAVE ME A READING OF 1/1000th OF A SECOND AT f8! ANOTHER WAY IS TO OVER-EXPOSE TWO STOPS .. 1/500 OF A SECOND AT f5.6 AND THEN UNDERDEVELOP FOR 25% LESS TIME!

REMEMBER: FOR COLOR SLIDES, IT'S THE OTHER WAY— EXPOSE FOR THE HIGHLIGHTS INSTEAD!

LIGHTING

HERE ARE SOME EXCELLENT EXAMPLES OF PICS THAT ARE EXPOSED FOR THE SHADOW AREA!

NOTE EYESOCKETS ARE NOT DARK

AND NOTICE HOW NICE SKIN LOOKS?

HERE'S PAT.. A PRETTY GIRL IN SUN

NOTICE YOU CAN SEE HER EYES?

LIGHTING SELECTIVE FOCUS

IT MEANS JUST WHAT IT SAYS...SELECT JUST ONE THING IN YOUR PICTURE YOU WANT TO STAND OUT, USUALLY UP CLOSE TO THE CAMERA...AND THEN SHOOT WITH THE LENS *WIDE OPEN!*
THIS MEANS YOU MUST DO SOME THINKING..... BECAUSE THE WIDER OPEN THE LENS.....THE FASTER THE SHUTTER SPEED....*REMEMBER?* BUT WAIT A MINUTE..... YOU HAVE TO THINK AGAIN..... IF YOU USE THE WRONG KIND OF FILM OUTSIDE IN THE SUN, LIKE TRI-X, YOU'RE NOT GOING TO HAVE A FAST ENOUGH SHUTTER SPEED.....AND YOUR SELECTIVE FOCUS PICTURES ARE GOING TO BE OVER-EXPOSED!

HERE'S AN EXAMPLE:

NOTICE THAT THE CAMERA IS ABOUT 18 INCHES FROM DICK'S FINGERS!

USING TRI-X, AT ASA 400, THE TWO FINGERS GAVE ME A READING OF f2.8 AT 1/2000 OF A SECOND! THAT'S GREAT FOR MY BRONICA, BECAUSE THAT'S WIDE-OPEN! THE ONLY CATCH IS I DON'T HAVE 1/2000 OF A SECOND! IF I WANT 1/1000 OF A SECOND, I'D HAVE TO SHOOT AT f4! THAT'S NOT TOO BAD...EXCEPT THAT I *DON'T WANT* DEPTH OF FIELD!
SO I USED PANATOMIC-X AND SHOT AT f2.8 FOR 1/1000th OF A SECOND....*GOTT'A THINK!*

LIGHTING

NOTICE IN THESE EXAMPLES OF SELECTIVE FOCUS, THAT THE CAMERA WAS CLOSE TO THE SUBJECT! COMING CLOSE MAKES THE BACKGROUND MORE OUT OF FOCUS, MAKING THE SUBJECT LIKE THE FEET, POP RIGHT OUT!

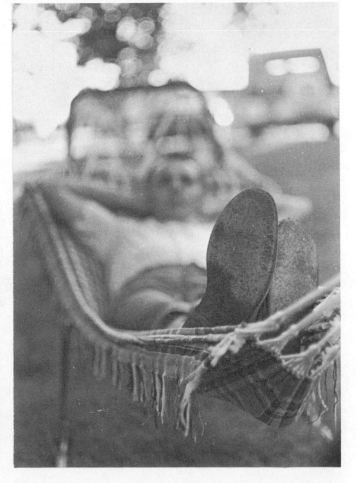

EXAMPLES OF LIGHTING

EVEN-LIGHTING

OPEN SHADE

BRIGHT SUN

ELECTRONIC FLASH

SUNLIGHT WITH WHITE CARD REFLECTOR

ELECTRONIC-FLASH

OPEN SHADE

ONE LIGHT AND WINDOW LIGHT ON LINDA'S RIGHT!

ONE LIGHT!

WINDOW LIGHT

EVEN-LIGHTING

EVEN LIGHTING

BRIGHT SUN — NO REFLECTOR

LIGHTING

USUALLY, THE LIGHT IN BUILDINGS, OR ROOMS, COMES FROM DIRECTLY ABOVE.... AND THAT'S THE **PROBLEM**, BECAUSE THE LIGHT FROM DIRECTLY ABOVE CAUSES BLACK EYE SOCKETS! THE PROBLEM CAN BE PARTIALLY SOLVED BY OPENING UP THE LENS ANOTHER STOP, IN THIS CASE, OR USING THE NEXT SLOWEST SHUTTER SPEED!

ANOTHER THING YOU HAVE TO DO IS BOOST THE FILM INDEX TO A HIGHER RATING, AND DEVELOP FOR A LONGER TIME OR SWITCH TO A HIGH-ENERGY DEVELOPER... SUCH AS *ACUFINE* (SEE THE SECTION ON DEVELOPERS) I'VE FOUND VERY SATISFACTORY RESULTS USING TRI-X AT AN INDEX OF 800, AND GIVING IT THREE EXTRA MINUTES IN D-76... ONE TO ONE, AT 68° ALSO TRI-X AT 1200, IN ACUFINE, 1:1

AS A STUDENT, THE BULK OF YOUR PICTURES WILL BE TAKEN OUTSIDE, OR BY EXISTING LIGHT INSIDE... AND MOST INDOOR SITUATIONS, SUCH AS CLASSROOMS, OFFICES, OR WINDOW LIGHT, CAN BE HANDLED WITH TRI-X OR SUPER HYPAN, WITHOUT PUSHING! JUST WATCH OUT FOR CONDITIONS WHEN YOUR LIGHT-**METER NEEDLE DOESN'T MOVE!**

REMEMBER— DON'T MIX YOUR ROLL ... I MEAN, DON'T SHOOT LOW-LIGHT PICTURES ON THE SAME ROLL WITH YOUR OUTDOOR PICTURES IF YOU DO, YOU'RE GOING TO HAVE TO DECIDE WHICH ONES YOU WANT TO DEVELOP FOR AND FORGET ABOUT THE REST!
SHOOT ONE TYPE OF PICTURE - ALL ON THE SAME ROLL!

I SEE YOU HAVE ONE OF THOSE NEW PORTABLE TV CAMERAS!!!

YEH, AND THESE LITTLE GEMS ARE REALLY CONVENIENT!

LIGHTING EXISTING LIGHT

BY EXISTING LIGHT, I MEAN THE LIGHT THAT IS NATURAL FOR THAT LOCATION WITHOUT ADDING ADDITIONAL LIGHTS, MAKING IT BRIGHTER! THE PICTURE OF ALAN KASS, AT RIGHT, NOTED ILLUSTRATOR AND INSTRUCTOR, IS A PERFECT EXAMPLE OF AN EXISTING-LIGHT PHOTOGRAPH! NOTICE THERE ARE NO BLOCKED-UP SHADOWS OR BURNED-OUT HIGHLIGHTS! THE TWO PROBLEMS WITH EXISTING-LIGHT ARE: *HAVING ENOUGH LIGHT.... AND A FAST EMULSION FILM IN YOUR CAMERA..* ...LIKE KODAK TRI-X OR SUPER HYPAN (**GAF**) MOST EXISTING LIGHT SITUATIONS ARE LOW ON EXISTING LIGHT, AND THE FILM NEVER SEEMS TO BE FAST ENOUGH.. OR ELSE THE NEEDLE DOESN'T MOVE ON YOUR METER!

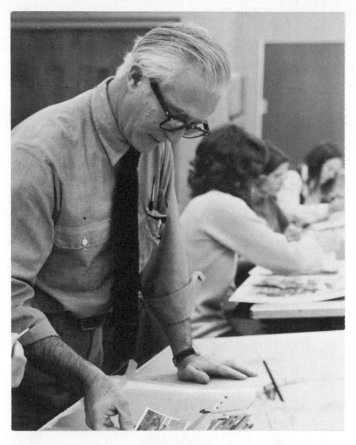

JIM MACKEY IS A GOOD EXAMPLE OF A POOR EXISTING LIGHT PICTURE! *NOTICE THE BLACK EYE SOCKETS?*

LIGHTING

HERE ARE
SOME EXISTING-
LIGHT SHOTS
WITH FILM AND
DEVELOPER INFO

PLUS-X, D-76 TRI-X, UFG

TRI-X AND ACUFINE TRI-X AND D-76

ANSCO VERSAPAN AND RODINAL TRI-X AND ACUFINE

LIGHTING MORE EXISTING-LIGHT!

AGFA ISOPAN RECORD – HYFINOL

TRI-X AND D-76

ILFORD HP4 – ACUFINE

PLUS-X AND D-76

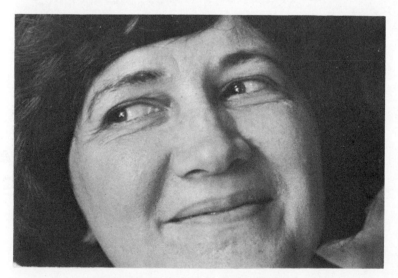

ROYAL-X PAN, DK-50

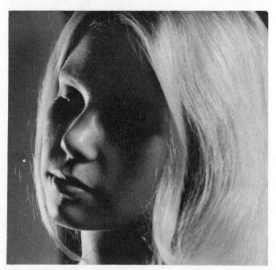

PLUS-X AND D-76

HIGH CONTRAST

WITHOUT A DOUBT, THIS TECHNIQUE OF PRINTING PICTURES IN A VERY HIGH CONTRAST IS THE MOST FUN OF ANYTHING YOU'LL DO....AND I PROMISE IT'LL HOOK YA!

BUT IT'S A GIMMICK AND ONLY SERVES SPECIAL PURPOSES.......SUCH AS COPYING LINE DRAWINGS, BLOWING UP LETTERING OR ART WORK FOR POSTERS,AND REDUCTIONS!

AND OF COURSE MAKING A DRAWING OF YOUR FRIENDS OR YOUR CAR....OR EVEN SCENERY... *HAVE FUN!*

HIGH CONTRAST

FIRST OF ALL LET'S HAVE A LOOK AT WHAT THIS FILM CAN DOTHE NAME OF THE FILM IS KODALITH ORTHO FILM 6556 TYPE 3....BUT WE'LL JUST CALL IT *"KODALITH"!*
STUDY THE PHOTOS BELOW.... ONE IS A NORMAL PRINT....THE OTHER A KODALITH! NOTICE THAT THE FILM DOESN'T SEE RED OR GRAY! IT SEES THE GRAY AS DOTS, AND THE REST OF THE PICTURE AS JUST WHITE OR BLACK!

HERE'S A REGULAR FULL SCALE PHOTO

AND HERE'S THE KODALITH

HIGH CONTRAST

HERE'S AN EXAMPLE OF REDUCING AND BLOWING UP ART WORK!

FANTASTIC BLOW-UPS AND REDUCTIONS ARE POSSIBLE SINCE THE FILM HAS NO GRAIN!

I COULD HAVE MADE IT SMALLER BUT YOU WOULDN'T HAVE BEEN ABLE TO READ IT!

THIS IS ABOUT THE SIZE IT WOULD BE IN THE FUNNY PAPERS!

THIS IS ABOUT AN 11X14 PRINT!

AND THIS IS A 16X20 PRINT!

HIGH CONTRAST

NOW.....LET'S GO THROUGH THE WHOLE BIT SO YOU CAN SEE HOW IT'S DONE...THE SAME PROCEDURE IS ALSO TRUE FOR LOADING UP TRI-X, PLUS-X, OR COLOR...*EXCEPT YOU MUST DO IT IN TOTAL DARKNESS!!*

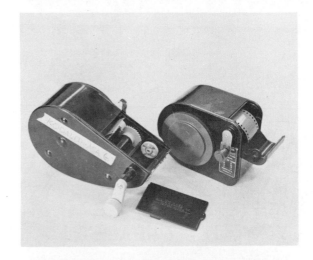

FIRST YOU NEED A DAYLIGHT LOADER FOR 50 OR 100 FT. ROLLS OF KODALITH...ONE OF THESE TWO MODELS WILL DO VERY NICELY! *INEXPENSIVE!*

HERE'S KODALITH FILM...THIS IS THE 100 FT. ROLL! IT'S A LOT CHEAPER THAN TRI-X OR PLUS-X AND BE SURE IT'S PERFORATED SO IT WILL MOVE THROUGH YOUR CAMERA! *READY!?*

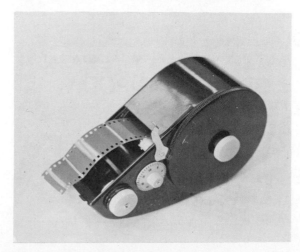

IN THE DARK, OR UNDER A RED SAFE-LIGHT, LOAD YOUR FILM INTO THE DAYLIGHT LOADER LEAVING THE END STICKING OUT*LIKE THIS!*

HIGH CONTRAST

I'M TIRED OF ALWAYS BEING IN THE DARK!

DON'T LOAD YOUR FILM IN ROOMLIGHT!

LOAD UP ABOUT A DOZEN EXPOSURES FOR A TRIAL RUN! AS YOU CAN SEE, TRI-X AND PLUS-X.. EVEN COLOR CAN BE USED THIS WAY! IT'S CHEAPER!

KODALITH DOES NOT COME IN 120 FOR 2¼ X 2¼ CAMERAS! YOU'LL HAVE TO BUY A FILM MAGAZINE... *LIKE THIS!* REMEMBER...THEY CAN BE USED OVER AND OVER AGAIN!

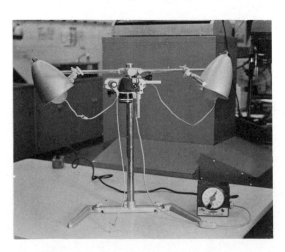

NEXT, YOU'LL NEED A COPY STAND TO KEEP YOUR CAMERA STEADY!...OR YOUR TRIPOD, WITH THE PICTURE TO BE COPIED TAPED ON THE WALL! YOU'LL USE LONG EXPOSURES BECAUSE THE FILM SPEED OF KODALITH IS ONLY 6!

HIGH CONTRAST

DON'T TRY TO PUSH THE FILM LONGER IN THE DEVELOPER...*IT WON'T WORK!*

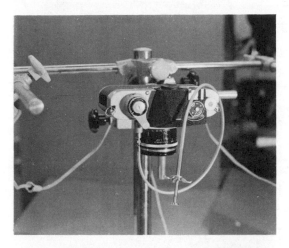

PLACE ONE ORDINARY PHOTO BELOW THE CAMERA AND SET YOUR SHUTTER SPEED ON THE "B" SETTING! *(BULB)*.... AND YOUR f STOP ON THE BIGGEST OPENING *(LOWEST NUMBER)*

SET YOUR TIMER CLOCK FOR TWO SECONDS...OR YOU CAN USE THE SWEEP SECOND HAND ON YOUR WATCH!

NOW, WITH THE CABLE RELEASE IN YOUR HAND...PUSH IT IN.... THAT WILL HOLD THE SHUTTER OPEN AS LONG AS YOU HOLD THE PLUNGER IN...*NOW*..TURN THE LIGHTS ON FOR 2 SECONDS AND TAKE THE PICTURE!

HIGH CONTRAST

DON'T FORGET.... KODALITH DOES NOT SEE RED!

READY... ADVANCE YOUR FILM TO THE NEXT FRAME AND STOP THE LENS DOWN TO THE NEXT SMALLEST STOP... PROBABLY f2 OR f2.8.... AND DO THE SAME THING AGAIN!

DO THIS WITH EVERY STOP ON YOUR CAMERA! f1.8, f2.8, f4, f5.6, f8, f11, f16 f22, ETC, ETC. THIS IS CALLED "BRACKETING"

DON'T FORGET TO TAKE ONE PICTURE AT EVERY STOP THAT YOU CLICK TO! NOW... CRANK YOUR FILM BACK IN AND LOAD IT IN YOUR DAYLIGHT TANK!

FINE LINE DEVELOPER

THIS DOES THE BEST JOB AND COMES IN POWDER FORM AS "A" AND "B" SOLUTION! 2½ MINUTES WITH FIVE SECONDS AGITATION EVERY 15 SECONDS! BE SURE TO BRACKET TO FIND THE CORRECT EXPOSURE!

DEKTOL

FOR MANY YEARS WORKING IN TELEVISION WE USED KODALITH FILM DEVELOPED IN DEKTOL PAPER DEVELOPER WITH GREAT RESULTS! DILUTE IT WITH ONE PART WATER TO ONE PART DEVELOPER AND TRY 45 SECONDS WITH CONTINUOUS AGITATION AT ABOUT 68°

KODALITH LIQUID DEVELOPER

THIS IS WHAT PRINTERS USE TO MAKE LARGE NEGATIVES FOR OFFSET PLATES! "A" AND "B" SOLUTIONS IN LIQUID FORM! DEVELOPE FOR 2½ MINUTES AND AGITATE 5 SECONDS EVERY 15 SECONDS!

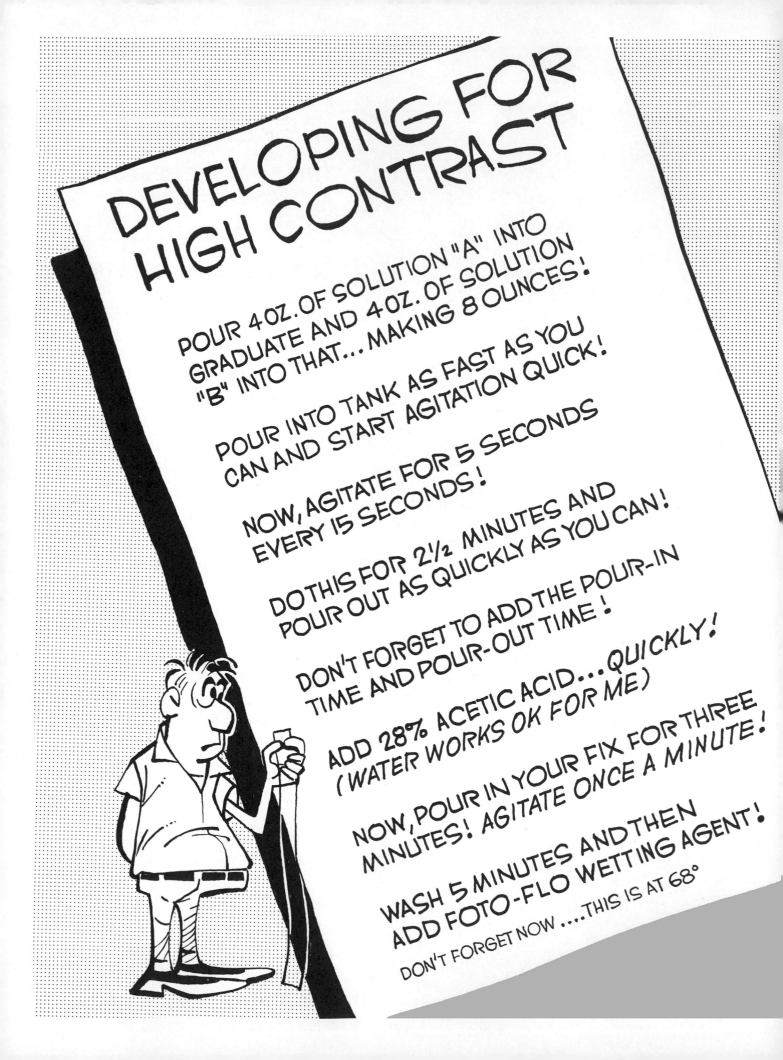

HIGH CONTRAST

TO SAVE YOURSELF ALOT OF GRIEF AND WASTED TIME, LOOK BELOW AND SEE THE RESULT OF COPYING A FLAT, LOW CONTRAST PRINT, MADE FROM A THIN, UNDEREXPOSED NEGATIVE!

YOU PROBABLY HAVE ALOT OF THESE PRINTS!
FORGET IT!

USE ONLY SNAPPY PRINTS... BUT BETTER STILL THE ONES TAKEN OUTDOORS TURN OUT THE BEST.... PROVIDED THEY'RE EXPOSED AND DEVELOPED CORRECTLY!

HERE'S THE BAD PRINT!

AND HERE'S THE KODALITH!

HIGH CONTRAST
LOOK WHAT YOU CAN DO IN THE ENLARGER!

SECTION OF 8X10 NORMAL PRINT!

5 SECONDS

KODALITH

10 SECONDS

KODALITH

15 SECONDS

KODALITH

25 SECONDS

KODALITH

HIGH CONTRAST
THE BEST PRINTS FOR HIGH CONTRAST ARE THOSE PRINTED ON THE LIGHT-SIDE AND TAKEN OUTDOORS!

THIS WOULD TAKE HOURS TO DRAW...

HIGH CONTRAST
THERE'S NO LIMIT TO BLOW-UPS!

SECTION OF 8X10

SAME SIZE KODALITH

HERE'S
THE
TEENIE
WEENIE
PRINT
OF
LINDA

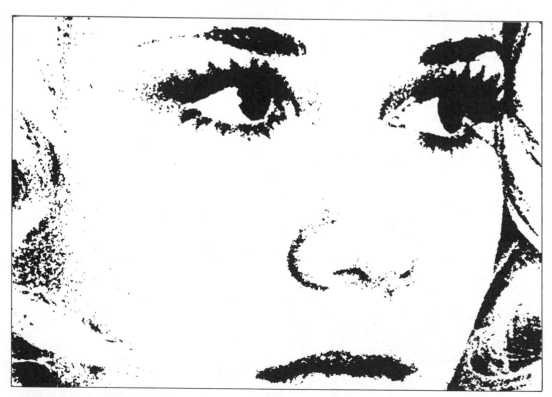

SECTION OF 16X20 KODALITH......

HIGH CONTRAST

THE TOP PICTURE IS A BLACK AND WHITE
REPRODUCTION OF A COLOR PRINT.
THE BOTTOM IS A KODALITH COPY !

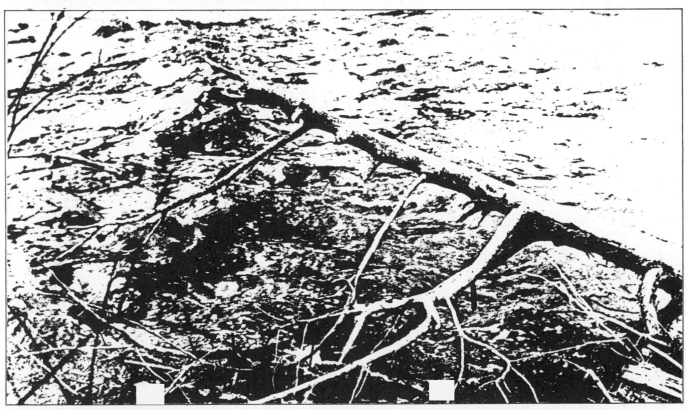

HIGH CONTRAST

BELOW IS A FUNNY SITUATION THAT HAS BEEN REDUCED TO HALF SIZE FROM THE ORIGINAL WITH KODALITH FILM!

WATCH OUT FOR REFLECTIONS...TURN AND SEE!

HIGH CONTRAST

JUST ABOUT ANYTHING CAN BE COPIED IN HIGH CONTRAST... IF THESE PICTURES BELOW WOULD HAVE BEEN SHOT WITH ORDINARY FILM, THEY WOULD HAVE AN OVER-ALL GRAY EFFECT!!

FROM A NEWSPAPER

HIGH CONTRAST COPY

FROM A MAGAZINE

HIGH CONTRAST COPY

HIGH CONTRAST

FLARE IS ALWAYS A PROBLEM WHEN YOU COPY PHOTOS...IN FACT ANY PHOTO WILL SHINE BACK AT THE CAMERA AND SPOIL YOUR PICTURE !

SEE THOSE THINGS THAT LOOK LIKE CLOUDS? WELL, THEY'RE NOT.....*THAT'S FLARE !*

THE SOLUTION IS TO BUY A CAN OF MATT SPRAY AT AN ART OR PHOTO STORE...AND SPRAY THE PICTURE !

HIGH CONTRAST

TAKEN FROM THE TOP OF THE EMPIRE STATE BUILDING IN THE SUMMER OF 1960, THIS IS A GOOD EXAMPLE OF THE KIND OF PRINT TO GO FOR IN MAKING A HIGH CONTRAST PRINT... *KEEP IT ON THE LIGHT SIDE!*

HIGH CONTRAST

THE KODALITH COPY IS FANTISTIC AND WOULD TAKE AN ARTIST DAYS TO DRAW.... IF HE WAS CRAZY ENOUGH TO TRY IT....
COLORED WITH MAGIC MARKERS, IT'S BEAUTIFUL!

IF YOU'RE IN A PINCH
YOU CAN USE A & B
SOLUTION TO DEVELOPE
ORDINARY FILM ... BUT
YOU WON'T GET THE
BEST DEFINITION!

I USED PANATOMIC-X
FILM AND SHOT IT AT
THE RECOMMENDED
FILM SPEED OF 32!

I SHOT AT f 5.6 AT
1/125 OF A SECOND
ON A TRIPOD ... NOT
A REAL SHARPY!

THIS IS THE 8X10

LOOK AT THIS 16X20 FROM SAME NEGATIVE

HIGH CONTRAST

HERE'S SOMETHING INTERESTING.... I TOOK AN AD FROM AN 1890 MAGAZINE AND BLEW IT UP TO A 16X20! THESE ADS MAKE GREAT THINGS TO FRAME AND HANG ON YOUR WALL *SOME ARE REALLY FUNNY!*

THIS ONE IS THE EXACT SIZE OF AD!

HERE'S AN 8X10!

AND HERE'S AN 11X14 AND A BIG 16X20!

STUDY LAW AT HOME

Instruction by mail, adapted to everyone. Original. Approved. Experienced and competent instructors. Takes spare time only. Three courses; Preparatory and College Law Course; also Business Law Course. Improve your condition and prospects. Graduates everywhere. Nine years of success. Full particulars free.
Sprague Correspondence School of Law, 350 Majestic Bldg., Detroit, Mich.

HIGH CONTRAST

NOTICE THE OVER-ALL GRAY YOU GET WHEN YOU USE THE ORDINARY FILM.... AND THE BEAUTIFUL BLACK AND WHITE CRISP PRINTS YOU GET WHEN YOU USE KODALITH!

THIS 16X20 PRINT BELOW IS FROM PANATOMIC-X...35mm

HIGH CONTRAST

HIGH CONTRAST

KODALITH IS ALSO PRODUCED IN LARGE SIZE LIKE 8X10, 11X14, 16X20 AND LARGER..... IT'S CALLED "GRAPHIC ARTS FILM", AND IS USED TO SHOOT LARGE NEGATIVES FOR THE MAKING OF PLATES IN PRINTING SHOPS! YOU COULD PURCHASE IT AND USE IT LIKE ENLARGING PAPER AND DEVELOPE IT RIGHT IN YOUR TRAY OF DEKTOL JUST LIKE A REGULAR PRINT! *FANTASTIC!*

GOOD THINGS ABOUT KODALITH!

CAN WORK UNDER RED SAFE-LIGHT
HIGHEST POSSIBLE CONTRAST
SHORT DEVELOPING TIME
FILM DRIES IN ABOUT 5 MINUTES
PRINTS ON ALL PAPER GRADES
PRINTS IN BLACK AND WHITE
EASY TO TOUCH-UP
GREAT REDUCTIONS
BIG BLOW-UPS
FUN – FUN – FUN – FUN

BAD THINGS ABOUT KODALITH!

RED COMES OUT BLACK
SPECIAL PURPOSES ONLY
MUST USE COPY-STAND
NEED SPECIAL DEVELOPER
MUST LOAD YOUR OWN
DRUGSTORES DON'T HAVE IT
FILM SPEED TOO SLOW

SOME KODALITH POSSIBILITIES...

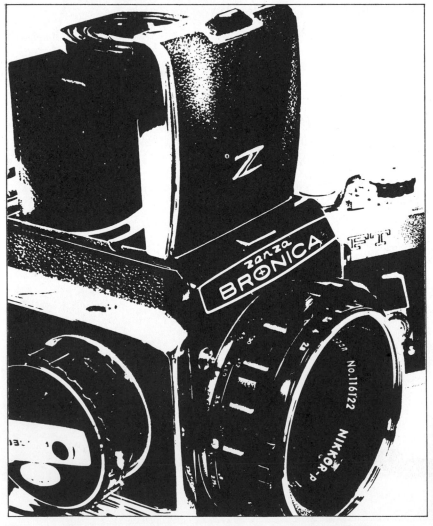

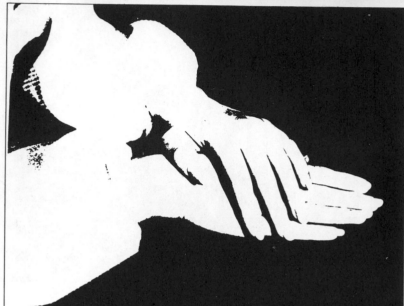

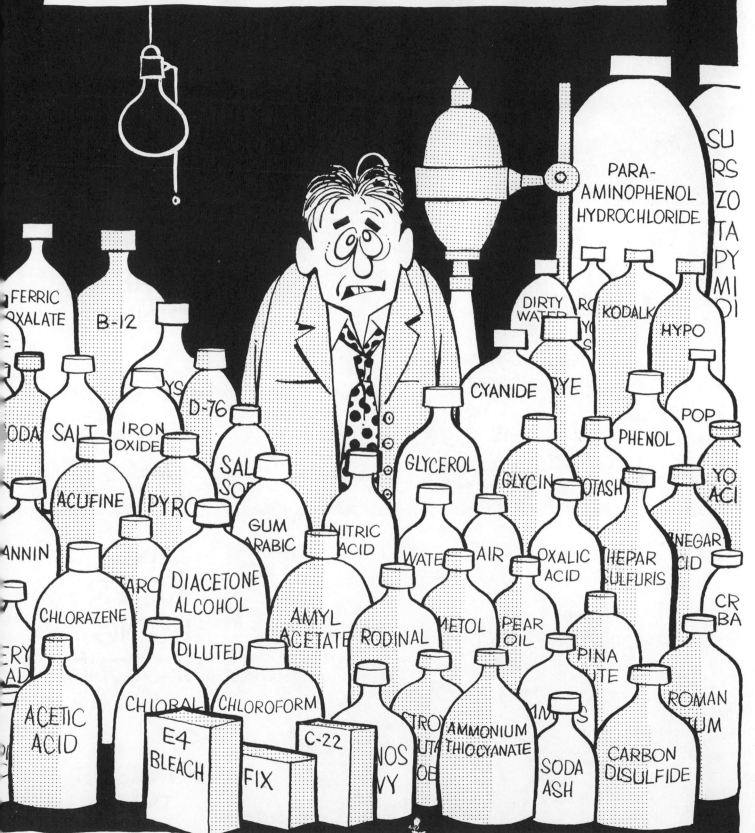

PHOTO LAB

THIS IS "SPOTONE"... IT COMES IN NUMBERS ONE, TWO, AND THREE! WITH A SMALL NO. 1 OR 2 BRUSH... AND YOUR SPIT FOR DILUTION, IT WILL SPOT-OUT ALL THE DUST AND HAIRS THAT PRINT ON YOUR PICTURE! GET A NUMBER THREE!

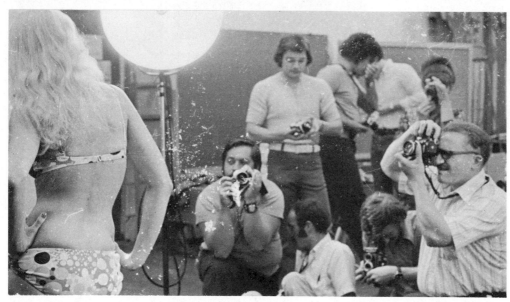

HERE'S THE PRINT

IT'S A MESS ISN'T IT?

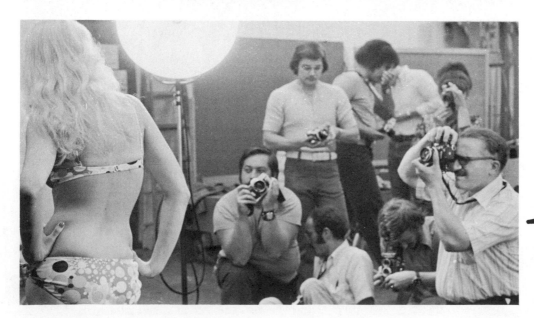

AND AFTER USING SPOTONE

HOW ABOUT THAT?

THE GRAIN FOCUSER!

YOU'LL NEVER KNOW WHAT A SHARP PRINT IS UNTIL YOU USE A GRAIN FOCUSER! THAT'S A DEVICE THAT REFLECTS PART OF THE ENLARGED IMAGE OFF OF A MIRROR, WHICH IS THEN VIEWED THROUGH A HIGH-POWERED EYEPIECE OF ABOUT 10X TO 20X! WHAT YOU REALLY SEE IS THE GRAIN ON THE NEGATIVE ... AND THAT IS WHAT YOU FOCUS ON IF YOU WANT A SHARP PICTURE!

THIS FOCUSING AID IS MADE BY BAUSH AND LOMB AND IS ABOUT 10 POWER! MOST ARE AROUND THAT MAGNIFICATION!

THE TWENTY POWER SCOPONET, MADE IN FRANCE, IS THE VERY BEST ON THE MARKET.... NOT ONLY THAT.... BUT IT'S EXPENSIVE!

PHOTO LAB

HERE'S A SECTION OF A 16X20 PRINT, MADE WITHOUT A FOCUSING AID! IT LOOKED SHARP WHEN I FOCUSED IT!

AND HERE'S THE SAME PRINT MADE WITH MY TRUSTY SCOPONET FOCUSING AID! 20X MAKES THE DIFFERENCE!

PHOTO LAB
UNDER-EXPOSURE!

NOT ENOUGH LIGHT REACHING THE FILM DURING
EXPOSURE IN THE CAMERA, CAUSED BY TOO FAST
OF A SHUTTER SPEED OR TOO **SMALL** OF A LENS
OPENING... OR A COMBINATION OF BOTH! IN ANY
EVENT DON'T WASTE YOUR TIME ON THIS NEGATIVE!
IF YOU HAVE TO SAVE IT YOU COULD USE SOME
INTENSIFIER.....OR ANOTHER WAY IS TO PRINT ON
A NO.4 OR NO.5 ENLARGING PAPER! EVEN A 6!

PHOTO LAB
NORMAL NEGATIVE!

THIS WILL BE A JOY TO PRINT ON A NORMAL
PAPER BECAUSE THE WHITES, BLACKS, AND ALL
THE GRAYS ARE THERE! YOU SHOULD STRIVE
TO HAVE YOUR WHOLE ROLL OF NEGATIVES COME
OUT LIKE THIS! THE BIG REASON BESIDES A
BEAUTIFUL PRINT IS THAT YOU HAVE LESS WORK
BECAUSE ONE TEST PRINT FOR THE CORRECT
EXPOSURE AND THEY'LL ALL PRINT THE SAME!

PHOTO LAB
OVER-EXPOSURE!

MUCH TOO MUCH LIGHT REACHING THE FILM
DURING EXPOSURE IN THE CAMERA, CAUSED BY
TOO SLOW OF A SHUTTER, TOO LARGE OF A LENS
OPENING....OR A COMBINATION OF BOTH! YOU
COULD USE A REDUCER..........OR SWITCH TO A
NO.2 OR EVEN A NO.1 PAPER! IN ANY EVENT, YOU
WILL GET A GRAINY PICTURE WITH A TERRIBLE
LOSS OF DEFINITION AND DIFFICULT TO PRINT!

PHOTO LAB
HERE'S A LIGHT·METER!

NOTICE THE ASA IS SET FOR 100? THAT'S FOR PANATOMIC-X THAT WILL BE DEVELOPED IN ACUFINE ONE-TO-ONE!

A READING WAS TAKEN OUTDOORS IN THE SUN-LIGHT AND READ AT **13** WHICH IS WHERE THE TRIANGLE IS SET. (ARROW)

SEE HOW IT READS: f8 FOR 250th OF A SECOND, PLUS ALL THE OTHER COMBINATIONS!

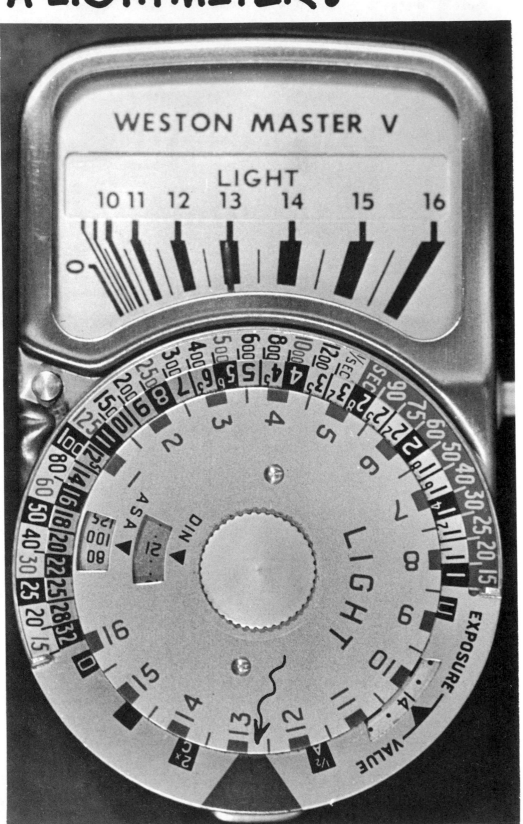

PHOTO LAB THE ENLARGER!

AN ENLARGER MUST THROW LIGHT ON THE NEGATIVE EVENLY, AND IT MUST BE A BRIGHT ILLUMINATION OR THE EXPOSURE BECOMES TOO LONG, CAUSING ANOTHER DEADLY PROBLEM: *VIBRATION!* SOMEONE SLAMMING THE DOOR, A BIG TRUCK DRIVING BY.... OR JUST WALKING NEAR THE ENLARGER CAN CAUSE IT TO MOVE DURING EXPOSURE!

IF THE ENLARGER ILLUMINATION OF THE NEGATIVE IS UNEVEN, IT WILL GIVE A PATCHY PRINT.... OR HOTSPOTS!

MOST ENLARGERS ARE MADE CORRECTLY, AND THIS SORT OF PROBLEM, SUCH AS HOTSPOTS, DOESN'T EXIST!

WHEN BUYING AN ENLARGER, THE STURDIEST ONE IS THE ONE YOU WANT! ONE THAT DOESN'T VIBRATE EVERYTIME YOU BREATHE ...AND ONE THAT DOESN'T KEEP MOVING AFTER YOU FOCUS THE PICTURE!

ENLARGING LENSES: IF YOU CAN'T AFFORD BOTH.... A GOOD ENLARGER AND A GOOD ENLARGING LENS GET THE GOOD ENLARGER AND THE SECOND RATE LENS! A TOP RATED ENLARGING LENS WILL NOT GIVE A GOOD PRINT IF THE CHEAP ENLARGER IS MOVING DURING EXPOSURE... BUT THE SECOND RATE ENLARGING LENS WILL GIVE A SHARP PRINT IF IT IS HELD STEADY DURING EXPOSURE! MAKE SENSE?

DEAR...YOU'RE GETTING LARGER ENLARGER!

A TYPICAL ENLARGER

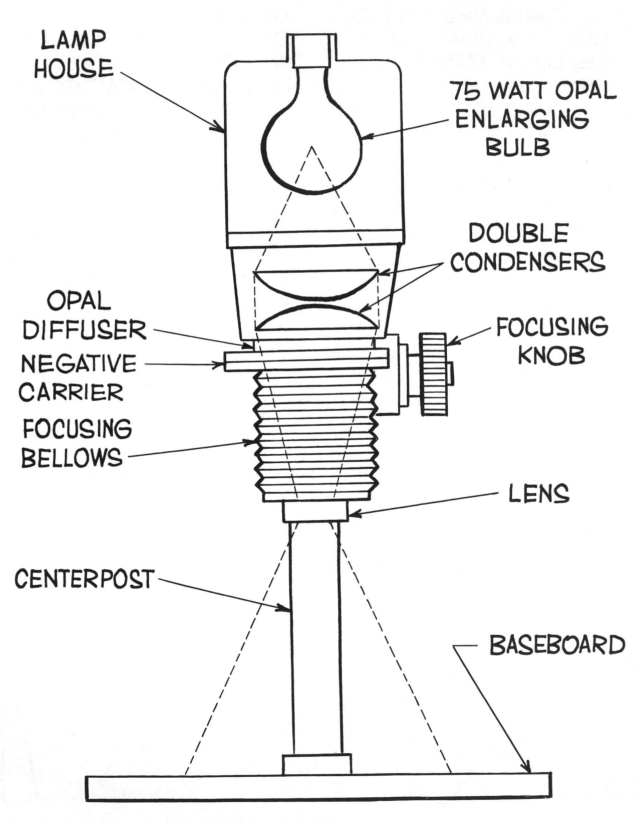

LAMP HOUSE

75 WATT OPAL ENLARGING BULB

DOUBLE CONDENSERS

OPAL DIFFUSER

NEGATIVE CARRIER

FOCUSING KNOB

FOCUSING BELLOWS

LENS

CENTERPOST

BASEBOARD

PHOTO LAB
HINTS ON FILM DEVELOPING!

CONTAMINATION:

OF MAXIMUM IMPORTANCE IS CLEANLINESS WHEREVER CHEMICALS ARE INVOLVED.... AND PHOTOGRAPHY IS NO EXCEPTION! ALL CHEMICALS ARE HIGHLY SUBJECT TO CONTAMINATION, AND IF YOU WANT TO AVOID A HEADACHE, KEEP BOTTLES, DEVELOPING TANKS, THERMOMETERS, REELS, SPONGES, TUMBLERS, AND OTHER ITEMS CLEAN! REMEMBER THAT WHEN YOU MIX CHEMICALS IN TOO HOT A WATER, HIGHER THAN IS RECOMMENDED BY THE MANUFACTURER, THIS CAN RESULT IN A COMPLETE BREAKDOWN OF SOME OF THE AGENTS IN THE DEVELOPER!

AGITATION:

AGITATION IS VERY, VERY ESSENTIAL IN OBTAINING THE PROPER DEVELOPMENT, AND MUST BE DONE WITH CARE AND CONSISTENCY! THE MAIN REASON FOR AGITATION IS THAT IN DEVELOPING, CERTAIN BI-PRODUCTS, PRIMARILY THE BROMIDES, ARE RELEASED DURING DEVELOPMENT! THESE BROMIDES WILL HINDER THE DEVELOPMENT, CAUSING SUCH THINGS AS, STREAKS, SPOTS, AND IRREGULAR EDGES! SO THEY MUST BE MOVED AROUND DURING AGITATION TO PREVENT THIS HAPPENING! YOU MUST START AGITATION IMMEDIATELY... AND I MEAN *IMMEDIATELY*..AS SOON AS YOU ADD THE DEVELOPER FOR THE FIRST TEN SECONDS!

TEMPERATURE:

KEEP THE SAME TEMPERATURE THROUGH-OUT THE PROCESS! IN MANY CASES PEOPLE THINK THEY HAVE TOO MUCH GRAIN IN THEIR PICTURES WHEN IT'S SLIGHT RETICULATION CAUSED BY THE VARIATIONS IN TEMPERATURE!

PHOTO LAB
SOME HINTS ON ENLARGERS!

GET THE STURDIEST YOU CAN AFFORD!

GET ONE THAT TAKES 35mm AND 2¼ x 2¼ NEGATIVES! THAT WAY IF YOU GO TO A BIGGER NEGATIVE IN THE FUTURE, YOU WON'T HAVE TO BUY ANOTHER ENLARGER... ONLY A LONGER FOCAL LENGTH 75 OR 80mm!

YOUR ENLARGER LENS SHOULD BE THE SAME FOCAL LENGTH AS YOUR NORMAL CAMERA LENS! *EXAMPLE:* THE NORMAL LENS FOR A 35mm CAMERA IS BETWEEN 45mm AND 58mm.... SO A 50mm ENLARGING LENS IS WHAT YOU SHOULD USE TO PRINT YOUR PICTURES! ON THE OTHER HAND, THE NORMAL LENS FOR A 2¼ CAMERA IS BETWEEN 75mm AND 80mm.... SO ANYONE OF THOSE TWO FOCAL LENGTHS WILL WORK FINE FOR THE 2¼ x 2¼ NEGATIVE!

USE A FOCUSING AID FOR SHARPER PRINTS!

PHOTO LAB

THE DURST-J35 IS A LITTLE 35mm ENLARGER THAT DOES A GREAT JOB! IT IS VERY LOW PRICED AND IS REALLY QUITE STURDY! THESE ARE ALL *USED* ENLARGERS!

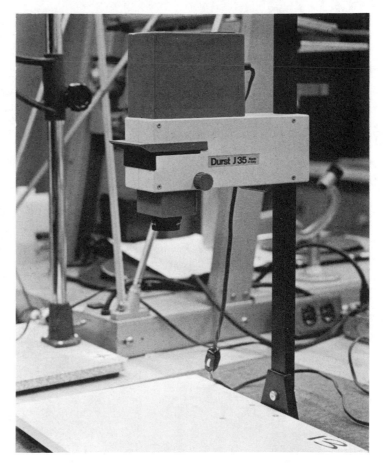

THE VIVITAR IS ANOTHER WELL MADE ENLARGER WITH A VERY GOOD LENS! IT STANDS UP WELL IN CLASS USE AND WILL DELIVER VERY SHARP PICTURES! A JOY TO USE! 2¼ AND 35mm NEGATIVES

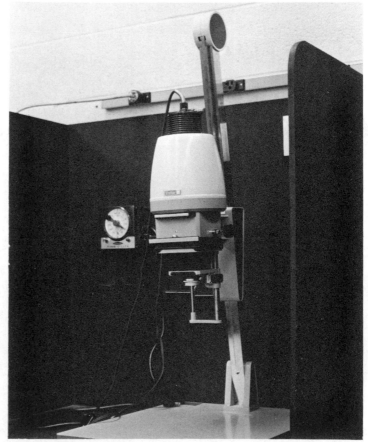

PHOTO LAB

THE OMEGA B22-XL IS THE FAVORITE OF MY STUDENTS! IT'S LIGHT, STEADY, AND GIVES OUT SHARP PICTURES! IT CAN TAKE 2¼ × 2¼ AND 35mm, JUST CHANGE CONDENSERS

THE BESELER 23C IS AN EXCELLENT ENLARGER MADE FOR THE PRO...... IT'S VERY STEADY, GIVES OUT RAZOR SHARP PICTURES AND HAS A KNOB THAT CHANGES THE CONDENSERS! TAKES 2¼ AND 35mm

PHOTO LAB

THIS BIG 4X5 BESELER IS MY FAVORITE! IT TAKES 4X5, 2¼ x 2¼, AND 35 NEGATIVES, AND ALL SIZES IN-BETWEEN! IT'S BUILT LIKE A BRICK POGODA!

THE ASTRALUX IS ANOTHER LOW COST ENLARGER THAT JUST TAKES 35mm NEGATIVES! WE MAKE COLOR PRINTS WITH THESE AND THEY COME OUT PRETTY GOOD! PRINTS ARE SHARP!

PHOTO LAB

BRACKETING!

ALL PROFESSIONAL PHOTOGRAPHERS BRACKET THEIR EXPOSURES!

LET US SAY FOR EXAMPLE YOU'VE TAKEN A METER READING OF A BOWL OF CORN FLAKES, WITH MILK AND SLICED BANANAS, AND IT READS ƒ16 FOR 1/30th OF A SECOND!YOU MAY HAVE **READ** YOUR METER IMPROPERLY, YOUR SHUTTER SPEED COULD BE SLIGHTLY OFF, OR MAYBE AFTER DEVELOPING, YOU DIDN'T LIKE THE LOOKS OF THE NEGATIVE.... OR ANY NUMBER OF OTHER PROBLEMS.... BUT THERE YOU ARESTUCK WITH **ONE NEGATIVE AND ONE EXPOSURE!** PRETTY STUPID ISN'T IT?.... BUT WHAT IF IT HAD BEEN A ONCE-IN-A-LIFE-TIME SHOT?

SO.....YOU BRACKET YOUR EXPOSURES ON THOSE REALLY IMPORTANT PICTURES IF YOU'RE NOT SURE OF THE EXPOSURE....OR DON'T HAVE A LIGHT METER! AS FOR EXAMPLE IN THE CASE OF THE BOWL OF CORN FLAKES.........SHOOT ONE AT 1/15th OF A SECOND, ONE AT 1/30th OF A SECOND (THE CORRECT EXPOSURE), AND ONE AT 1/60th OF A SECOND.....AND ONE OF THOSE SHOTS IS GOING TO BE **RIGHT ON!**

A SHORT QUIZ!

1. ONE FILM DEVELOPER WILL HANDLE EVERY SITUATION.

2. 1/250th OF A SECOND AT f8 IS THE SAME EXPOSURE AS 1/60 AT f16.

3. IF YOU DON'T HAVE A PAPER SAFE-LIGHT FOR PRINTING, YOU CAN USE THE LIGHT FROM A CANDLE.

4. THE BIGGER THE LENS OPENING THE SLOWER THE SHUTTER SPEED.

5. f1.4 TO f1.8 IS A FULL STOP.

6. 30 SECONDS MORE IN THE FILM DEVELOPER IS NOT GOING TO MAKE THAT MUCH DIFFERENCE.

7. PANATOMIC-X HAS FINER GRAIN THAN PLUS-X.

8. A 2¼ NEGATIVE GIVES SHARPER PICTURES THAN A 35mm NEGATIVE.

9. SELECTIVE FOCUS IS MORE EFFECTIVE WHEN SHOT AT INFINITY!

ANSWERS ARE ON THE NEXT PAGE!

THE ANSWERS...

1. THAT'S NOT TRUE! MICRODOL-X FOR EXAMPLE, WOULD BE A POOR CHOICE FOR PUSHING UP FILM SPEED.

2. YOU BET YOUR BUTTONS IT IS.

3. THAT'S TRUE AT 4 FEET.

4. NOPE... IT'S THE OTHER WAY AROUND.

5. SORRY... IT'S 2/3 RDS OF A STOP! f1.4 TO f2 IS ONE FULL STOP.

6. THE HELL IT'S NOT..... IT WILL BE GRAINIER AND HAVE MORE CONTRAST.

7. THERE'S NO DOUBT ABOUT IT.

8. YOU'RE NOT PAYING ATTENTION! THE LITTLE NEGATIVE IS JUST AS SHARP.... BUT GRAINIER, BECAUSE IT'S BLOWN-UP BIGGER IN RATIO TO THE 2¼ NEGATIVE.

9. AW, COME ON NOW... AT INFINITY EVERYTHING IS SHARP........ NO-MATTER WHAT THE LENS OPENING! INFINITY WOULD JUST CANCEL OUT THE WHOLE EFFECT!

BIBLIOGRAPHY

THERE ARE A LOT
OF PHOTO BOOKS
AROUND....I MEAN
A LOT!
IF I WERE TO LIST
ALL OF THEM, THIS
WOULD BE A BOOK
CATALOG...BESIDES,
THERE ARE ONLY
A FEW THAT THE
BEGINNING PHOTO
STUDENT CAN
BENIFIT FROM!
I'LL PROBABLY NOT
LIST YOUR FAVORITE
OR THE BEST PHOTO
BOOK IN THE WORLD!
ACTUALLY, I DIDN'T
REALLY INTEND TO
ADD THIS CHAPTER
BECAUSE I DIDN'T
FEEL LIKE LOOKING
THROUGH A LOT OF
PHOTO BOOKS JUST
TO FIND THE BEST

BIBLIOGRAPHY

PHOTO-LAB INDEX
LIFETIME ADDITION
MORGAN AND MORGAN, INC.
A MUST FOR YOUR LIBRARY...THEY
KEEP SENDING YOU NEW PAGES FOR
THIS BOOK AS CHANGES AND NEW

THINGS COME OUT...IF YOU SUBSCRIBE
TO THAT SERVICE! THE PRODUCTS OF
AMERICAN AND FOREIGN PHOTO-
GRAPHIC PRODUCTS, INCLUDING HOW TO
DEVELOP AND PRINT THEM ... PLUS
A WEALTH OF OTHER INFORMATION!

THE FOCAL ENCYLOPEDIA
OF PHOTOGRAPHY
McGRAW-HILL BOOK COMPANY
THIS IS ANOTHER MUST IN YOUR
COLLECTION! THERE ARE 2,400
ARTICLES BY 276 AUTHORS FROM
28 COUNTRIES WITH 1,699 PAGES
AND OVER 1,700 ILLUSTRATIONS!

THIS ENCYLOPEDIA, LIKE THE LAB
INDEX, IS A FANTASTIC BOOK! IT'S
LAYED OUT LIKE A DICTIONARY
AND EASY TO FIND EXACTLY
WHAT YOU ARE LOOKING FOR!
I WOULD RECOMMEND THIS AS A
FIRST IN YOUR LIBRARY, AND ONE
THAT YOU WILL BE GLAD THAT
YOU BOUGHT!

BIBLIOGRAPHY

WRITER'S MARKET
WRITER'S DIGEST PUBLICATIONS
THIS BOOK COMES OUT EVERY YEAR AND CONTAINS 4,361 MARKETS FOR THE FREELANCE WRITERS, CARTOONISTS, POETS, GAG MEN, PHOTOGRAPHERS, AND PUBLISHERS OF EVERY KIND OF MAGAZINE IN THIS COUNTRY! IT TELLS HOW TO PREPARE A MANUSCRIPT, HOW TO SEND YOUR PHOTOS, AGENTS, PICTURE SOURCES, SYNDICATES, GOVERNMENT INFORMATION SOURCES .. AND YOU NAME IT!

THE ENCYCLOPEDIA OF PHOTOGRAPHY
100 AVENUE OF AMERICAS NEW YORK, N.Y. 10013
A SET OF 20 VOLUMES OF GREAT BOOKS COVERING ALL FIELDS OF PHOTOGRAPHY A PERSON COULD BE INVOLVED! SOME AREAS COVERED: ALL THE KNOWN GREATS, ABSTRACTION, AERIAL, ANIMATION, CAREERS, CINEMATOGRAPHY, DOCUMENTARY, INDUSTRIAL, INFRARED, LAW ENFORCEMENT PHOTOGRAPHY, PORTRAITURE, MICROPHOTOS, COLOR PRINTS....IT'S ENDLESS!

BIBLIOGRAPHY

THE COMPLETE PHOTOGRAPHER BY FEININGER- PRENTICE-HALL

THIS IS A GOOD BOOK FOR THE BEGINNER AS WELL AS FOR THE PROFESSIONAL! IT TALKS ABOUT THE PERSONALITY OF THE GOOD PHOTOGRAPHER, TOOLS AND MATERIALS, HOW TO TAKE A GOOD PHOTOGRAPH, DEVELOPING AND PRINTING, THE SYMBOLS OF PHOTOGRAPHY! COLOR IS ALSO WELL COVERED IN THIS BOOK!

DARKROOM MAGIC BY LITZEL- CHILTON BOOKS

A GREAT BOOK FOR PHOTO NUTS WHO LOVE TO EXPERIMENT! THE CONTENTS INCLUDE: HIGH-CONTRAST, LINE DRAWING, SOLARIZATION, TONE SEPARATION, TEXTURE SCREENS, COMBINATIONS, NOTES ON DEVELOPMENT, AND SOME GREAT DARKROOM HINTS FROM YEARS OF EXPERIENCE! THIS IS A WELL WRITTEN BOOK THAT TELLS HOW TO DO ALL THOSE GREAT EFFECTS IN PHOTOGRAPHY! THIS BOOK COULD BECOME YOUR FAVORITE!

BIBLIOGRAPHY

KODAK PHOTO INFORMATION BOOKS!

MOST PHOTOGRAPHERS AREN'T AWARE OF ALL THE
BEAUTIFUL LITTLE INFORMATION BOOKS THAT THE
EASTMAN KODAK COMPANY PUTS OUT! JUST ABOUT
EVERYTHING YOU WOULD WANT INFORMATION ON IS
IN THESE BOOKS! HERE ARE SOME OF THE TITLES:
HERE'S HOW, FILTERS AND POLA-SCREENS, SLIDES,
SLIDES AND FILM STRIPS, MICROSCOPE PHOTOGRAPHY,
COLOR PHOTOGRAPHY, FILMS FOR SCIENTIFIC AND
TECHNICAL USE, KODAK FILMS, FLASH PICTURES, BASIC
DEVELOPING AND PRINTING, CHEMICALS AND FORMULAS!
I WOULD NEED SEVERAL PAGES TO LIST THEM ALL!

A WORD ABOUT COLOR

I'VE LEARNED OVER THE YEARS OF TEACHING, THAT IT'S ENOUGH OF A PROBLEM LEARNING THE BASICS OF GOOD BLACK AND WHITE DEVELOPING AND PRINTING WITHOUT INTRODUCING ALL THE RAMIFICATIONS OF COLOR TRANSPARENCIES AND COLOR PRINTING, AND CONFUSING THE STUDENT..... THIS IS WHY I'M NOT INCLUDING THE SUBJECT IN THIS BOOK, WITH THE ANTICIPATION OF COVERING IT AND OTHER VERY INTERESTING PHOTOGRAPHIC AREAS IN A FUTURE BOOK.... YOU CAN INTRODUCE YOURSELF TO COLOR VERY SIMPLY...JUST PURCHASE A ROLL OF COLOR SLIDE FILM OR COLOR NEGATIVE FILM, AND FOLLOWING THE INSTRUCTIONS ON THE INFORMATION SHEET PACKAGED WITH THE FILM! THOSE COMPANIES SPEND MILLIONS OF DOLLARS TO ASSIMILATE THAT INFORMATION AND YOU CAN BELIEVE WHAT IT SAYS!

MODEL RELEASE

For and in consideration of my engagement as a model by_____ , hereafter referred to as the photographer, on terms or fee hereinafter stated, I hereby give the photographer, his legal representatives and assigns, those for whom the photographer is acting, and those acting with his permission, or his employees, the right and permission to copyright and/or use, reuse and/or publish, and republish photographic pictures or portraits of me, or in which I may be distorted in character, or form, in conjunction with my own or a fictitious name, on reproductions thereof in color, or black and white made through any media by the photographer at his studio or elsewhere, for any purpose whatsoever; including the use of any printed matter in conjunction therewith.

I hereby waive any right to inspect or approve the finished photograph or advertising copy or printed matter that may be used in conjunction therewith or to the eventual use that it might be applied.

I hereby release, discharge and agree to save harmless the photographer, his representatives, assigns, employees or any person or persons, corporation or corporations, acting under his permission or authority, or any person, persons, corporation or corporations, for whom he might be acting, including any firm publishing and/or distributing the finished product, in whole or in part, from and against any liability as a result of any distortion, blurring, or alteration, optical illusion, or use in composite form, either intentionally or otherwise, that may occur or be produced in the taking, processing or reproduction of the finished product, its publication or distribution of the same, even should the same subject me to ridicule, scandal, reproach, scorn or indignity.

I hereby warrant that I am $\frac{under}{over}$ twenty one years of age, and competent to contract in my own name in so far as the above is concerned.

I am to be compensated as follows:

I have read the foregoing release, authorization and agreement, before affixing my signature below, and warrant that I fully understand the contents thereof.

DATED _____

_____L.S.
WITNESS

ADDRESS

_____L.S.
NAME

ADDRESS

I hereby certify that I am the parent and/or guardian of _____ an infant under the age of twenty one years, and in consideration of value received, the receipt of which is hereby acknowledged, I hereby consent that any photographs which has been, or are about to be taken by the photographer, may be used by him for the purposes set forth in original release hereinabove, signed by the infant model, with the same force and effect as if executed by me.

_____L.S
PARENT OR GUARDIAN

ADDRESS

Photographer: 1 - Fill in terms of employment.
 2 - Strike out words that do not apply.

SUMMARY

IF YOU'RE SERIOUS ABOUT BECOMING A PROFESSIONAL PHOTOGRAPHER, REMEMBER THAT IT'S NO COINCIDENCE THAT ALL THE GREAT PHOTO-GRAPHERS STUDIED ART! YOU MUST ALSO HAVE DRIVING AMBITION, TECHNICAL KNOW-HOW, A KEEN BUSINESS SENSE, AND HAVE A PLEASANT PERSONALITY......BECAUSE PHOTOGRAPHY IS 95 PERCENT MEETING PEOPLE! AND DON'T THINK OF PHOTOGRAPHY IN TERMS OF WEALTH AND EASY LIVING...IT'S THE SAME AS ANY OTHER ARTIST WORKING IN A CRAFT...YOU'RE GOING TO HAVE TO WORK HARD WITH IRREGULAR HOURS, AND SPEND SO MUCH TIME TRYING TO PLEASE CUSTOMERS THAT YOU WON'T HAVE TIME FOR FUN PICTURES! ONE MORE BIT OF ADVICE.... DON'T GET HUNG-UP ON THE GADGETS AND THE ENDLESS SEARCH FOR THE PERFECT CAMERA, THE PERFECT FILM, AND THE PERFECT DEVELOPER. THE RESULTS ARE MUCH MORE IMPORTANT THAN THE TOOLS! YOU'LL WORK HARD FOR YOUR REWARDS, BUT AN ARTIST WOULDN'T HAVE IT ANY OTHER WAY!

NOTES

INDEX